*Beginner's Guide to*

# Machine Embroidery

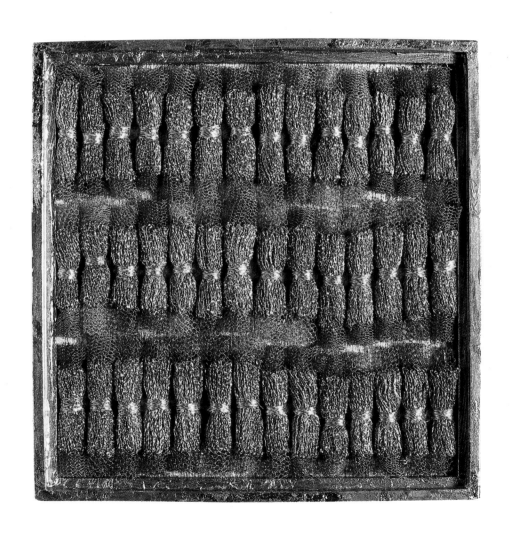

*For Martin and Simon*

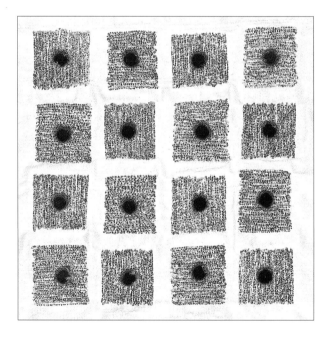

# Beginner's Guide to

# Machine Embroidery

## Pam Watts

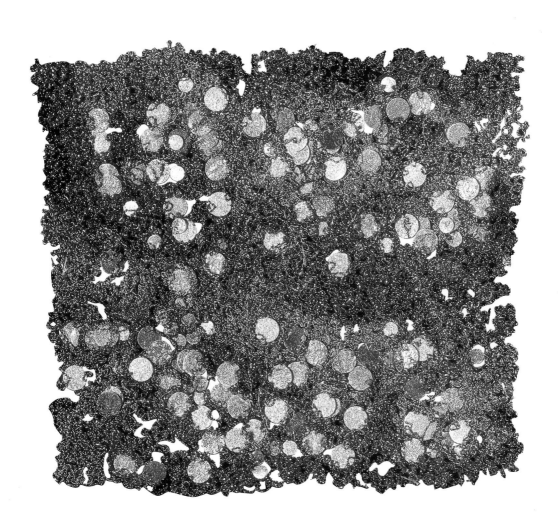

First published in Great Britain 2003
Search Press Limited
Wellwood, North Farm Road, Tunbridge Wells, Kent TN2 3DR
Text copyright © Search Press Ltd. 2003
Photographs by Search Press Studios
Photographs and design copyright © Search Press Ltd. 2003

Reprinted 2004, 2005

**Suppliers**
If you have difficulty in obtaining any of the materials and
equipment mentioned in this book, please visit our website
at www.searchpress.com.

Alternatively, you can write to the publishers, at the address
above, for a current list of stockists, including firms which operate
a mail-order service.

**Publisher's note**
All the step-by-step photographs in this book feature the author,
Pam Watts, demonstrating machine embroidery. No models have
been used.

Printed in Spain by A. G. Elkar S. Coop. 48180 Loiu (Bizkaia)

*I would like to thank my friends and colleagues
for their encouragement and my students, past
and present, for their endless support and enthusiasm
for machine embroidery.*

*My thanks to Alastair McMinn of Coats Craft UK
for continuing to supply me and my students with
machine embroidery threads, to Jim Chapman of
The Woking Sewing Centre for supplying and looking
after my sewing machines and to my brother, John,
for his technical help in writing this book.*

*Special thanks to all the staff at Search Press,
particularly to Ally and Juan for their hard work,
to Roz Dace for her help and support and to Lotti
for making the photography sessions so much fun.*

*Cover*

*Massed lines of straight, zig-zag and satin stitch were stitched on
silk fabric with added fragments of net, organza and sheers.*

*Page 1*

*Size: 11 x 11cm (4½ x 4½in)*

*Squares of space-dyed net on water soluble fabric were stitched
with close lines of free running stitch. After dissolving the fabric,
the squares were rolled up and tied, by hand, with gold machine
embroidery thread, then applied to a silk background.*

*Page 2*

*Size: 10 x 10cm (4 x 4in)*

*Squares of free running stitch were worked on silk fabric using
metallic thread. The central hole in each square was burned
through from the back using a pyrography pen.*

*Page 3*

*Size: 10 x 10cm (4 x 4in)*

*Circles of painted pelmet interfacing were cut out using a hole
punch. The circles were sandwiched between two layers of water
soluble fabric and stitched with granite stitch.*

*Page 5*

*Size: 7 x 23cm (3 x 9in)*

*This embroidery was completed using all the stitch techniques
featured in this book, including straight and zig-zag stitch, satin
stitch, granite stitch, braiding foot, tailor tacking foot and applied
strips of net and painted fusible adhesive mesh.*

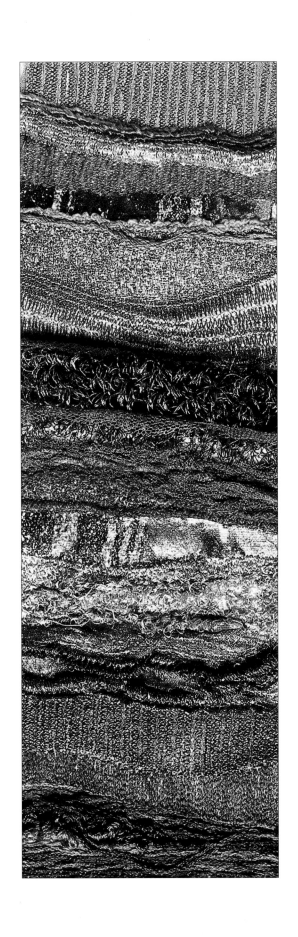

# Contents

# Introduction

A sewing machine is a familiar sight in many households. Often, it is simply used for mending and altering, or making clothes and items for the home – but even the simplest machine can also be used to produce wonderful, exciting and colourful embroidery.

Many people, myself included, were introduced to embroidery as a hand technique. Some people still think of machine embroidery as commercial: visions of mass-produced bed linen in department stores and sew-on motifs spring to mind. Others, when they hear that I use a machine to embroider, say: 'Oh, that's cheating, isn't it?' – as though the machine does all the work. But as soon as you begin to use a machine for embroidery, you realise it is a partnership. Yes, the machine works hard, but I choose the design, the threads, the colours, the fabrics and where – and how – it will stitch. The machine helps you to be creative and to interpret every whim of your imagination. More than that, it is the most fun you can have!

You may be nervous about using your machine for embroidery. I know students at my workshops worry theirs will not 'sew properly' afterwards, or that making unfamiliar alterations will somehow damage it. Nothing could be further from the truth: I honestly believe machines like embroidering! Think of a car, making endless short shopping trips or school runs, when what it really wants is a long run on the motorway. Your machine is just the same: a nice long afternoon embroidering is exactly what it needs. When you return to ordinary sewing, you will have new skills and ideas to add special decorative touches to your work – and a happy machine too!

I have been a machine embroiderer for more than twenty years, but even now I seem to discover something new and exciting every time I sit at the machine: a new way of carrying out a technique or combining patterns, understanding a little-used feature or using a wonderful thread I have not tried before. I am constantly amazed at the complexity of a sewing machine, and yet how simple it is to use.

I know everyone shudders at the terrible phrase 'practice makes perfect' because we want to do beautiful embroidery right now, but it really is the secret of success. I hope the ideas in this book will inspire you, and help to give you the skills and confidence to succeed.

*Pam Watts.*

*Opposite*
*Size: 18 x 12cm (7 x 5in)*
*Metallic, velvet and patterned ribbons were cut into squares and rectangles and bonded to a background fabric. These were stitched in place using lines of straight stitch, triple stitch – a basic utility stitch available on most machines – and couched chenille thread using the braiding foot.*

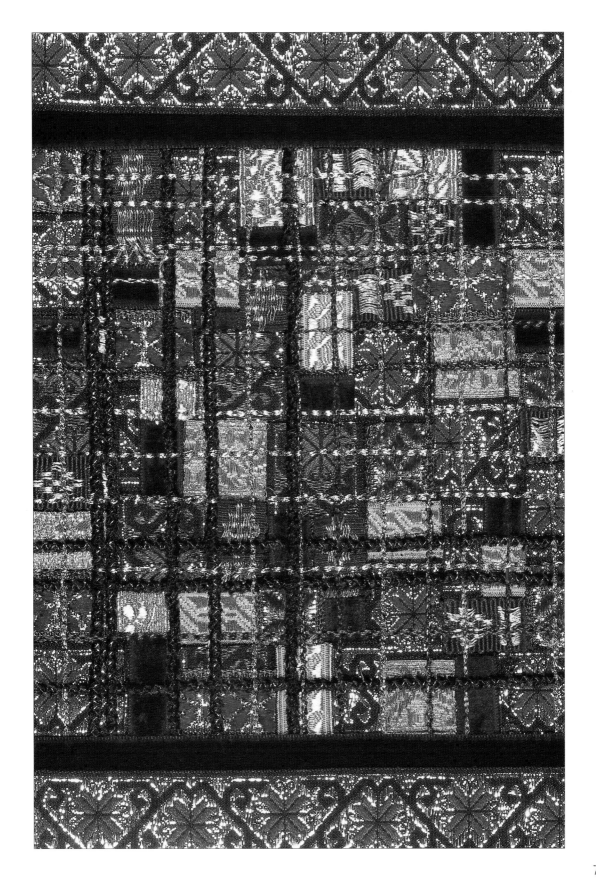

# Materials

**Sewing machine** Contrary to what many people think, you do not need an expensive, 'top of the range' model for machine embroidery. The only essentials are that your machine will do straight and zig-zag stitch and that you can drop or cover the feed dog or teeth. Instructions for this will be in the manual, usually under 'darning'. A few utility or decorative automatic patterns are useful extras. Make sure you have **sewing machine oil** as the all-purpose lubricating oil is too thick, and the little **cleaning brush** and **screwdriver** supplied with the machine.

**Feet** Your machine will be supplied with a number of presser feet. Make sure you have a darning foot: if not, order one from your supplier.

**Needles** Unlike hand embroidery needles, machine needles become blunt very quickly and you will need to change them regularly. Keep a store of good quality machine needles in sizes 90, 100 and 110. Size 110 are often sold as 'jeans' needles.

**Bobbins** Machines are usually supplied with only three or four bobbins. For machine embroidery, you will need lots. Always buy bobbins made specifically for your make of machine and, to keep them tidy, invest in a special container.

**Frames** For free machine embroidery you will need a ring frame. Metal spring ring frames made specially for machine embroidery are available in two sizes, or use a wooden embroidery ring frame.

**Scissors** You will need a pair of scissors for cutting fabrics, a pair for paper and a pair of small, fine pointed scissors for cutting threads.

**Pins** You can use standard or glass headed pins.

**Iron** I prefer to use an old-fashioned flat iron as it is slightly heavier. Heat settings and efficiency of thermostat can vary, so check how hot your iron gets, particularly at the higher range. When ironing silk or delicate fabrics or using fusible mesh, cover with baking parchment as a precaution.

**Baking parchment** This non-stick silicone paper is one of the most useful products to have around and is available from most supermarkets. Use a large piece to protect your ironing board, especially when using fusible adhesive mesh, and cover delicate fabrics with it before ironing. Greaseproof paper may look similar, but it is not 'non-stick'.

**Fusible adhesive mesh** This dry adhesive mesh is backed with non-stick paper. When ironed, it bonds two fabrics as in appliqué, and can also be used to transfer fabric paints to fabric. It is available in packets or by the metre from department stores, craft shops and specialist embroidery suppliers.

**Water soluble fabric** This is available from craft shops and specialist embroidery suppliers. Some types dissolve in hot water and some in cold: most stock the cold water soluble type. This is a clear plastic film in various weights or, more recently, a type which resembles lightweight fabric. Pin the embroidery to a piece of firm **foam** or **polystyrene tile** after dissolving the fabric.

**Water soluble marker** This is like a felt tip pen but the drawn line can be removed with water. To do this, I use a cotton bud dipped in tepid water.

**Stiletto** A stiletto or cocktail stick is useful to position or manoeuvre fragments of fabric into place while stitching.

For transferring designs, you will also need **white tissue paper, ruler, pencils, felt-tip** or **gel-based pens** in various colours and **adhesive tape**.

# Threads and fabrics

Everyone has reels of thread left over from dressmaking or household sewing. These can be used for embroidery, but you will be amazed at the difference in your stitching when you use threads made specifically for machine embroidery.

When you see a display of machine embroidery threads, it is like a new box of chocolates: you just have to have some – and then some more! The choice is amazing: as well as hundreds of single colours, there are ombré (tones of the same colour), variegated or multi-coloured (a mix of different colours) and plain threads with coloured flecks. Most are made from rayon, which gives the stitching a lovely sheen, but they are also made in polyester, acrylic, cotton and silk. They are available from specialist embroidery suppliers, craft shops and some department stores and are usually sold in 200m (209yd) reels or more economical 1000m (1095yd) reels. They come in different thicknesses or weights: the higher the number, the thinner the thread. The most usual is 40 but some threads are 50 or 60.

The range of metallic threads is also huge and even more alluring. As well as gold, silver and copper, there are coloured metallics from brightest red to palest blue; variegated metallics and coloured metallics twisted with black. These are particularly lovely as the shine of the metal is subdued by the black. Everyone is drawn to the 'supertwist' range of glistening textured metallic threads. These are a little more delicate than the smooth metallics, so I recommend that you reduce the top tension by half and use a large 110 needle to work with them.

Start by buying a few reels in your favourite colours and add to your collection whenever you can. Keep threads in a covered container away from sunlight as they can easily become dry and brittle.

## Fabrics

Most embroiderers have a store of oddments of fabric, and hoard anything that could possibly be stitched on. There are wonderful shops which sell chiffon, organza, shot silk, nets and novelty fabrics. Specialist embroidery suppliers will also have these fabrics in small quantities. Most of the other fabrics you will need are easy to find: calico, cottons, muslin and silk.

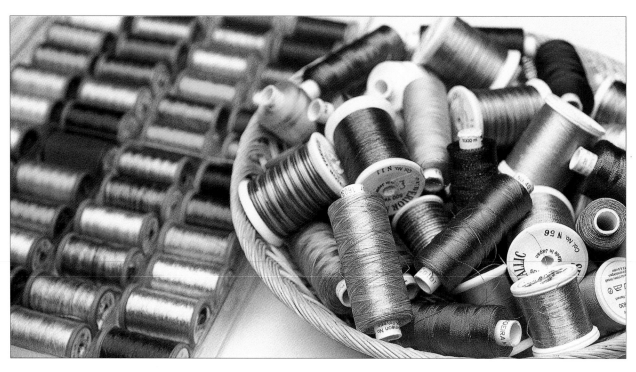

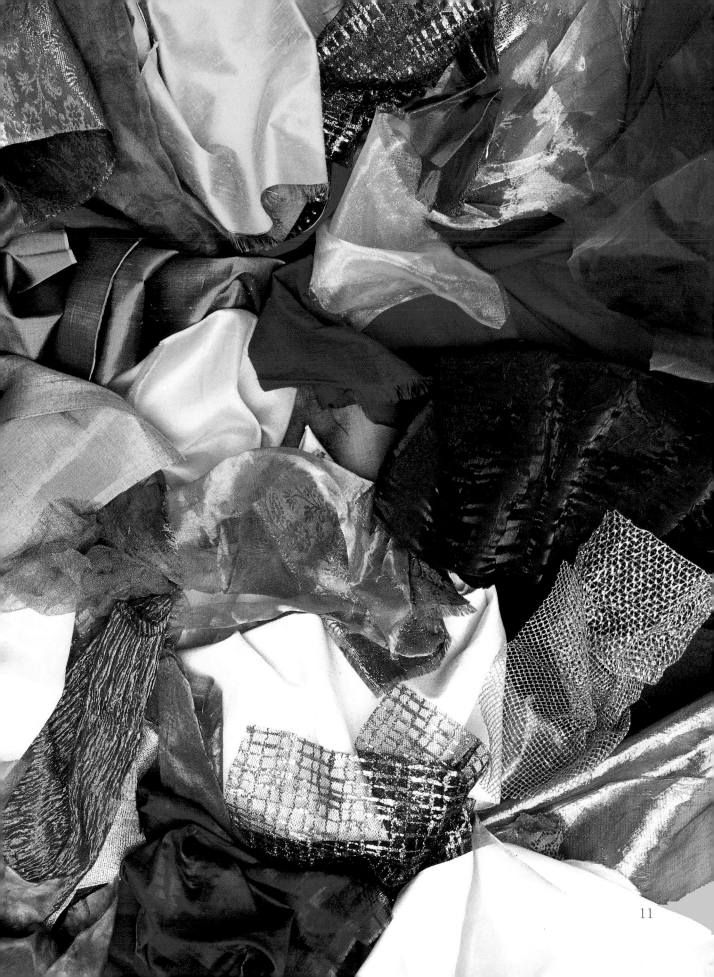

# Using the machine

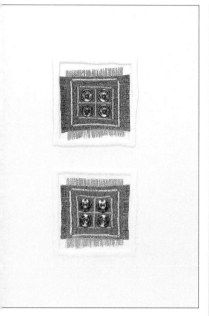

*A very narrow zig-zag was stitched in a grid pattern on two pieces of shot silk fabric. Press studs were sewn by hand into each of the squares. The fabric was frayed back to the stitched lines and applied to a card blank.*

Your machine's requirements are very simple. It likes to be warm and clean, and it likes to be used. The more you use it, the better it seems to stitch. Keep it in a warm room ready to use, not in a cold cupboard under the stairs. Warm it up before you start any project by stitching on a spare piece of fabric. Clean it regularly; it is amazing how much fluff collects, especially round the bobbin and under the stitch plate. Use the brush supplied; tweezers are useful to remove any odd bits of thread. Oil it as recommended, always using sewing machine oil, *not* all-purpose lubricating oil which is too thick.

Take time to read the manual. This sounds boring but controls do vary and even after many years of stitching I still discover new things about my machines. Familiarise yourself with stitch width and length controls, needle positions, balancing automatic patterns and whether you can set the needle to stop in the 'down' position. I suspect that many of us do not use the full range of features, just as we use a few programmes on our washing machine and forget the rest!

Beginners tend to avoid altering or adjusting tension settings, but these are easy to understand. The *spool* or *thread tension* will have a numbered dial or plus and minus settings. Selecting a higher number, or moving the dial towards (+), increases the tension; selecting a lower number, or moving the dial towards (−), decreases it. On most machines, the bobbin case has a tension screw. Draw a diagram showing the original angle or position of the slot in the screw head. Then, whatever alteration you make, you can return easily to the original tension. This is easy to remember: turning the screw clockwise increases the tension (right = tight), and turning it anti-clockwise decreases it: (left = loose). I think of the slot in the screw as hands on a clock, so I might increase or decrease the tension by ten or fifteen minutes. You may notice, particularly in free stitching, that little blobs of the bobbin colour come to the surface. This means the bobbin tension is too loose. Turning the screw ten minutes to the right may solve the problem. The tensions are sensitive, so make only small adjustments.

If something does not work as hoped, my students often say: 'my machine does not like that'. The truth is that a machine does not have opinions: you may have threaded it incorrectly or forgotten something simple, like selecting a stitch but not its width. A machine will do what you ask, if it is possible!

My best advice is to make time to be inquisitive. Compare pieces stitched using the maximum or minimum stitch lengths or widths. Stitch on different fabrics: on felt, lines of pattern sink into the surface; on velvet, they can hardly be seen but the surface will be textured. Increase the spool tension, stitch on organza and the fabric will pucker and gather. Stitch on an envelope or across the page of a letter you are about to send. Machining is a lot of fun!

*Opposite*

*Rectangles of furnishing velvet on backing fabric were overlaid with fragments of patterned organza. Random, gently curving lines of automatic patterns were stitched across in rayon and metallic threads. The edges were covered with applied braids, which were further decorated with lines of automatic patterns.*

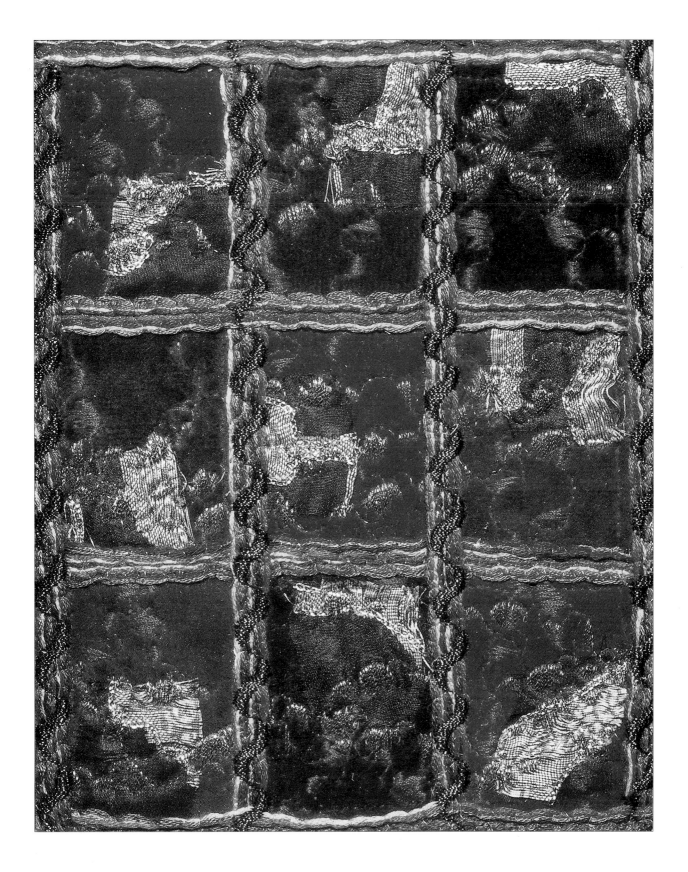

*Straight stitch showing different stitch lengths*

## You will need

Calico backing fabric
25 x 15cm (10 x 6in)

Silk fabric in the same
size as the calico

Chiffon in the same
size as the calico

Ruler

Water soluble marker

Blending or variegated
machine thread

Selection of smooth
and textured yarns
including wool, silk
and metallics

# Couched threads

Couching is the simplest of techniques, but it looks extremely effective and is fun to stitch. Traditionally, this is a hand technique, but the machine makes it quicker to work and produces hard-wearing and practical embroidery. You could make your first piece into a little bag to hold jewellery or to give as a present. When you are familiar with the technique, you can plan larger projects, such as cushions, incorporating threads to match your decor.

The main requirement for couching is a selection of thick, smooth and textured threads. You may have a collection of knitting, weaving, embroidery or novelty threads waiting to be used, or you can pick up unusual and interesting knitting yarns in sales. Thinner threads, narrow ribbons and metallic threads can also be used. Plan a colour scheme that appeals to you, perhaps using varied tints, tones and shades of one colour, or arranging threads from dark to light across the work. A really exciting, colourful thread could be used on its own to great effect.

The following project is worked on silk, but this is not absolutely necessary: any medium weight fabric, such as cotton, is suitable. Choose fabric in a colour that blends with the overall colour theme of the threads and back it with calico for stability. A layer of chiffon is placed over the threads to make the stitching easier and to stop the presser foot tangling in the threads.

The machine should be set for straight stitch using the standard presser foot and normal tension. Wind the bobbin with thread in a colour that blends with your work. Use the same thread on top, or try a shaded or variegated thread. Practise stitching on a spare piece of fabric, and experiment with different stitch lengths, from very short to very long, to add interest and variety.

Many variations are possible with couched threads. You can curve the lines of stitching rather than working them straight or, if your machine offers a selection of patterns, try using these instead for an extra decorative effect. You can also omit the top layer of chiffon and stitch directly over the textured threads but do stitch more slowly and take care not to catch the threads on the presser foot. I am sure that, as you work, you will think of many more variations to try.

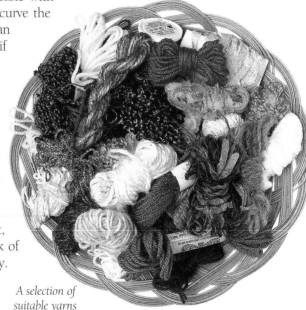

*A selection of
suitable yarns*

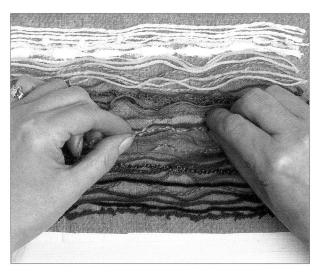

1. Place silk fabric on top of the calico backing. Lay the threads on the silk fabric, arranging the colours and textures in your chosen pattern.

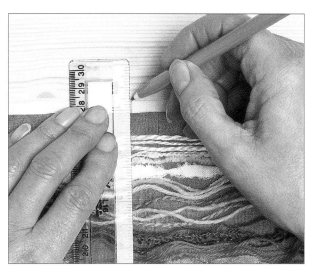

2. Mark the centre point of the fabric, top and bottom, using a ruler and water soluble marker.

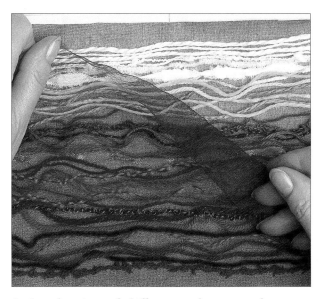

3. Lay the piece of chiffon over the arranged threads.

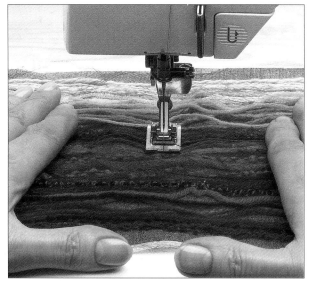

4. Beginning at the centre point and, using your water soluble marks as a guide, sew a line of straight stitches from top to bottom of your work.

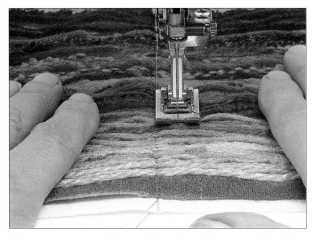 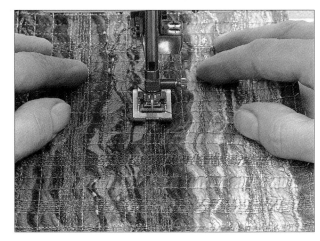

5. Turn your work round and machine another line of stitches parallel to the first, using the edge of the presser foot as a guide.

6. Continue to stitch lines from the centre to the edge of one side and then from the centre to the edge of the other side. Turn the work through 90°. Sew parallel lines as shown, making a grid pattern.

## *The finished embroidery*

*Additional lines of stitching have been inserted between some of the grid lines for extra texture and pattern.*

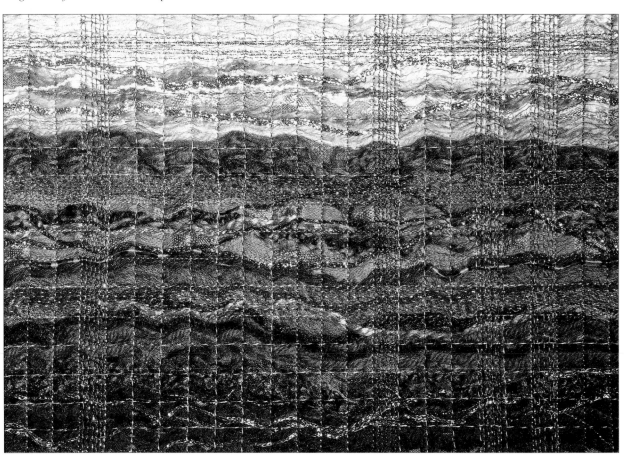

## Variation

*Size: 12 x 9cm (5 x 3½in)*

*A very textured, thicker yarn couched with a grid of stitching, but without a top layer of chiffon.*

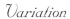

## Variation

*Size: 20 x 12cm (8 x 5in)*

*Textured threads, covered with chiffon, and stitched with a variety of automatic patterns using metallic threads.*

# Densely-stitched fabric

The massed lines of straight and zig-zag stitch and the fragments of brightly coloured fabric give a wonderful rich, textured surface to this embroidery.

Before you begin, make sure you are familiar with the controls that alter the stitch length and width. With most machines you can do this as you stitch, which results in lovely, tapering lines varying from wide to narrow and from open zig-zag to closer satin stitch. It takes a little while to become used to altering the controls while you are stitching and, at first, you may feel you need an extra pair of hands! Practise on a spare piece of fabric and try to stitch quite slowly, which will give you time to alter first the length, then the width of the stitch.

When you have chosen the background fabric, select a really good assortment of fabric including fine silk, organza, mesh, sheer and metallic fabrics. You can even include fragments of fine foil, interesting paper or sweet wrappers. Fabrics can be plain or patterned, but try to include some fairly dark colours as well as light and bright colours. These add to the overall vibrant effect, and will become integrated with the massed stitching.

You will also need a variety of colours of machine embroidery thread. When you make clothes or items for the home it is not usually necessary to change the thread colour; in machine embroidery, it is! When stitching, the spool colour should be changed quite often, but you will be surprised how quickly you can do this with practice. Use thread that matches the background fabric on the bobbin. Stitch a few lines with one colour, then another, then another, and towards the end of the stitching, work a few lines in metallic thread to add definition to the pattern. When you think you have done enough stitching, just a little more is required! Add a few more lines, ensure all the fragments of applied fabric are secure and stitched down, then add one more line of stitching – and it will be finished!

*The stitch sampler shows varied widths and lengths of zig-zag stitch.*

## You will need

Background fabric: silk or cotton
20 x 15cm (8 x 6in)

Backing fabric (calico is ideal) 20 x 15cm

Assortment of sheer and metallic fabrics

Scissors

Machine embroidery threads including metallic thread

Cocktail stick or stiletto

*The fabrics*

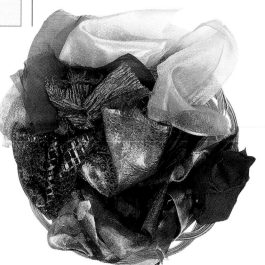

1. Place the background fabric on the calico backing. Take one of the sheer fabrics and fold or scrunch it up between your fingers. Hold it over the fabric and snip with scissors to produce irregularly shaped pieces. Repeat with the remaining fabrics.

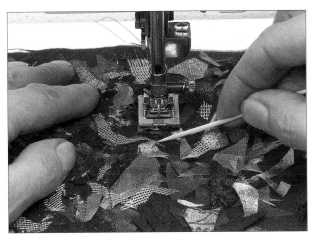

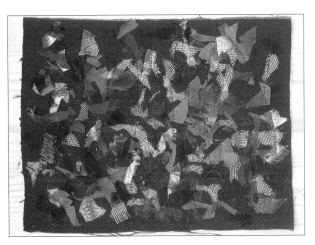

2. Using straight stitch, and starting at the centre, stitch curved lines both vertically and horizontally across your work. The applied pieces will move slightly under the presser foot but these can be controlled and adjusted with the help of a cocktail stick or stiletto.

3. Check to make sure all the fabric pieces are attached before beginning the zig-zag stitching.

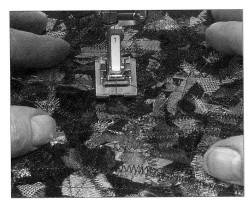

4. Curving the line and varying the stitch width and length, work lines of zig-zag stitch both horizontally and vertically, changing the thread colour regularly.

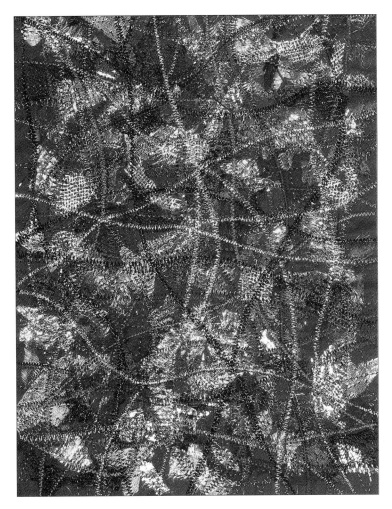

*The completed embroidery with massed, overlapping lines of straight and zig-zag stitch.*

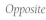

## Greetings cards

These were made by cutting embroidery into shapes and applying it to card blanks. The shapes can be glued to the card, but it is fun to stitch them directly to the card, then bring the sewing threads to the surface and tie them.

### Card 1 (top left)

A slightly larger piece of the embroidery was placed on corrugated paper. This was stitched through the corrugated paper on to the card beneath, following the grooves, and the thread ends were tied on the surface.

### Card 2 (top right)

Two squares of embroidery were glued to a card blank. The surface of the embroidery was dabbed with gold fabric paint using a paint brush.

### Card 3 (bottom right)

Three squares of embroidery were stitched to a piece of torn hand-made paper and glued to the front of a card.

### Card 4 (bottom left)

Nine squares of the embroidery were glued to the card surface. A piece of clear acetate was placed over the embroidery and stitched in place using straight stitch.

## Variation

Size: 15 x 20cm (8 x 6in)

The stitched embroidery was cut into small squares with sharp scissors and applied to a silk background. The squares were attached one at a time using zig-zag stitch in a medium width and length to cover the cut edge. The background fabric was frayed at the edges and mounted on fabric in a contrasting colour.

## Detail of fabric

Sheer fabrics and metallic foil fragments were placed on a hand-made paper background and stitched with massed lines of automatic patterns, using rayon and metallic threads.

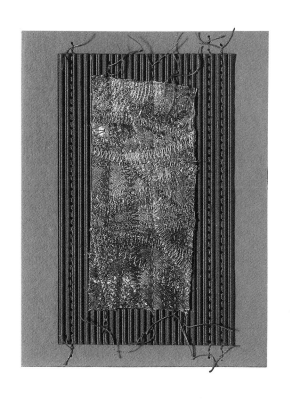

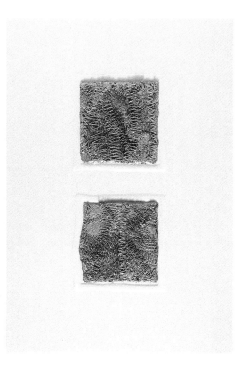

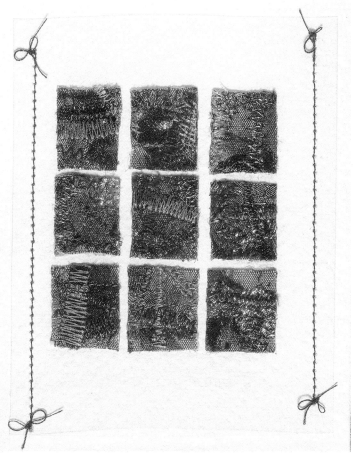

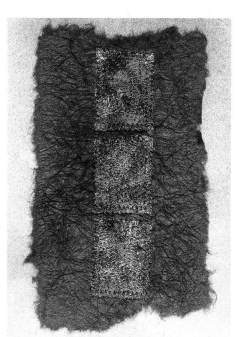

21

# Satin stitch

This stitch is often used for traditional machine appliqué, but can be used more creatively (see the stitch sampler left). Try a narrow stitch width first, then much wider, then alter the width as you stitch. For a wide satin stitch band you will need to work two rows side by side, but this can be difficult to do without gaps or overlapping the lines. The solution is to work two rows on the widest setting side by side, and as accurately as possible, then reduce the stitch width by half and stitch another line over the middle of the rows to cover any small discrepancies. On most presser feet, there is a mark in the middle of the foot that can be used as a guide to ensure an accurate middle line of stitching. This technique can be used to cover any area, and would look good covering the entire surface of a bag or book cover.

Many machines have a setting to alter the needle position, and this can be used to great effect with satin stitch. Start stitching, then move the needle position to make satin stitch blocks first on one side, then on the other. This can be worked to a regular pattern or irregularly. A twin needle can also be used. Satin stitch worked with a twin needle produces two narrow bands of stitching which can be very effective, especially in two contrasting colours, a colour and a metallic or two variegated threads. Follow the manufacturer's instructions for threading the machine and check the recommended maximum width for twin needle satin stitch. As an extra precaution, turn the hand wheel towards you to ensure that the twin needle will not hit the presser foot.

You may find that satin stitch puckers and wrinkles the fabric. One way to avoid this, especially on lightweight fabric, is to use a backing fabric. The machine's recommended stitch length for satin stitch may be too close for decorative work; increase it slightly and you should find the stitches sit more comfortably. Another possible solution is to reduce the top tension a little. This embroidery uses fragments of sheer fabric (see the technique on page 18), but this time they are bonded to the background fabric using paper-backed fusible adhesive mesh, which uses the heat of an iron to bond fabrics.

When you are using sheer fabrics, and as a general precaution, cover the ironing board and your work with baking parchment or non-stick silicone paper before ironing. Remember that greaseproof paper will not do – it will stick firmly to your work, as many an embroiderer has discovered!

*A variety of ways of working satin stitch, including altering the needle position and using a twin needle.*

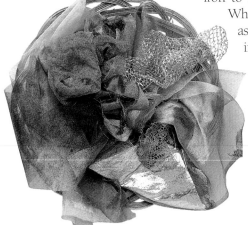

*Sheer and metallic fabrics*

## You will need

Silk or cotton fabric
20 x 15cm (8 x 6in)

Calico backing fabric in the same size

Assortment of sheer and metallic fabrics

Paper-backed fusible adhesive mesh
20 x 15cm (8 x 6in)

Iron and ironing board

Baking parchment or non-stick silicone paper

Scissors

Machine embroidery threads

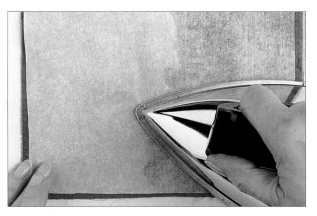

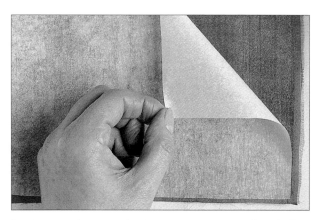

1. Protect your ironing board with baking parchment. Place the calico backing on the parchment with the silk or cotton fabric on top. Place the fusible adhesive mesh on the fabrics, checking carefully that the smooth paper side of the fusible mesh is uppermost (the adhesive side feels rough). Iron with a medium to hot iron.

2. Remove the paper backing, using a pin to detach the corner if necessary.

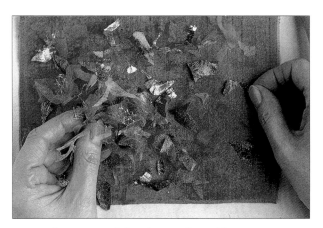

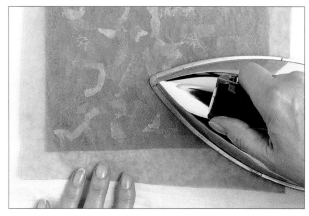

3. Cut fragments of the chosen sheer fabrics – see page 18, step 1 – and lay these on the fabric.

4. Cover with a slightly larger piece of baking parchment and iron firmly with a medium to hot iron, to fuse the fragments to the background fabric.

5. Peel back and remove the baking parchment, checking that all the fragments have been attached.

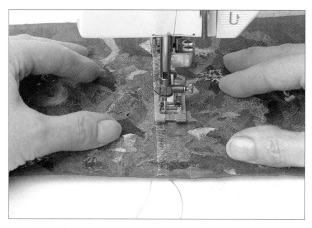
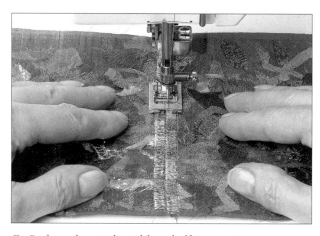

6. Select the widest stitch width and choose a thread colour. In the photograph above, a variegated thread is used. Stitch two rows of satin stitch, side by side.

7. Reduce the stitch width to half its previous setting and stitch a third line over the middle of the two previous rows.

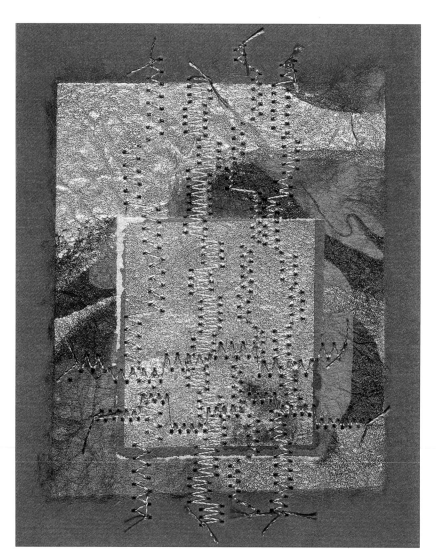

## Card with satin stitch

*A small square of gold tissue paper was placed on a larger piece of marbled, hand-made paper and both were placed on a card blank. Lines of zig-zag and satin stitch were worked through all three layers, using various needle positions.*

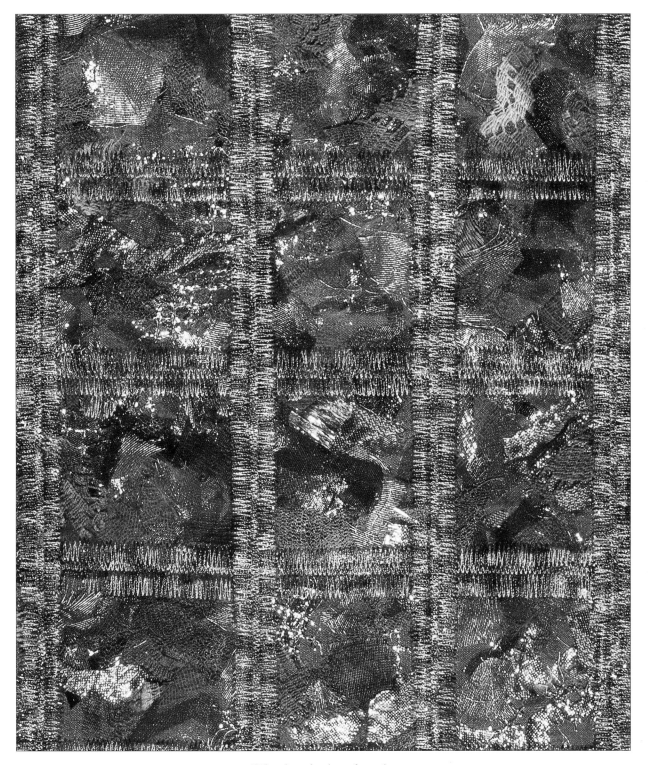

*The finished embroidery*

Bands of three lines of satin stitch were worked horizontally and vertically in a 'grid pattern,'
leaving little 3cm (1in) squares of brightly coloured fragments of fabric.

*Stitch sampler*

# Using the feet

When you buy a sewing machine, it will come with presser feet to enable you to carry out basic stitching techniques; how many will depend on the make and model of the machine. Your sewing machine dealer will also have an accessories list with an amazing array of extra items, including presser feet, which you may be tempted to buy.

## Braiding foot

The braiding foot makes it very easy to couch single strands of thicker threads, wools, narrow braids and ribbons, and it can also be used for raised or padded satin stitch. It has an oval hole, through which you pass the thicker thread: this is stitched down on to the fabric using either straight stitch or a narrow zig-zag. You can use any thread, smooth or textured, that will pass through the hole. A useful tip is to use the small screwdriver supplied with the machine to push or poke the thread through the hole.

Replace the standard presser foot with the braiding foot and thread your machine as usual. Collect a selection of thicker threads, thin ribbons and braids, and practise stitching using either straight or narrow zig-zag stitch. Try using a contrasting colour on the spool, or a metallic or variegated thread. If you use zig-zag stitch, make sure that the width of the stitch does not exceed the width of the hole in the foot. Adjust the length of the zig-zag and work it first as an open stitch, then reduce the length to achieve a close satin stitch that will cover the thick thread completely. This is called raised or padded satin stitch.

### You will need
Background fabric 18 x 15cm
(7 x 6in)
Braiding foot
Selections of thicker threads in different textures and weights
Scissors
Machine embroidery thread
Water soluble marker

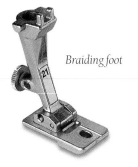

*Braiding foot*

*The threads and braids*

*Opposite*
*The finished embroidery*

Size: 15 x 12cm (6 x 5in)
*This landscape in cream, white and pale green, is worked using a variety of cotton, wool and silk textured threads. Some areas have been worked using the tailor tacking foot.*

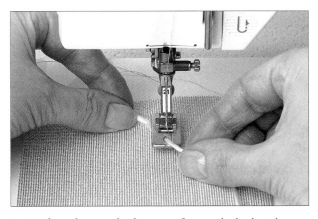 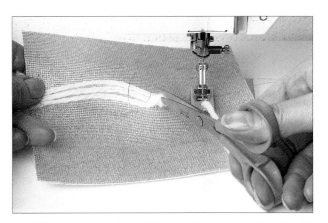

1. Replace the standard presser foot with the braiding foot and thread the machine in the usual way. Poke the thick thread through the hole in the foot and hold it at the front and back.

2. When an area of couching has been worked, snip off the ends of the thick threads close to the last machine stitch. These will be covered by subsequent lines of couching. You can use a water soluble marker on the fabric to define areas of stitching with different threads.

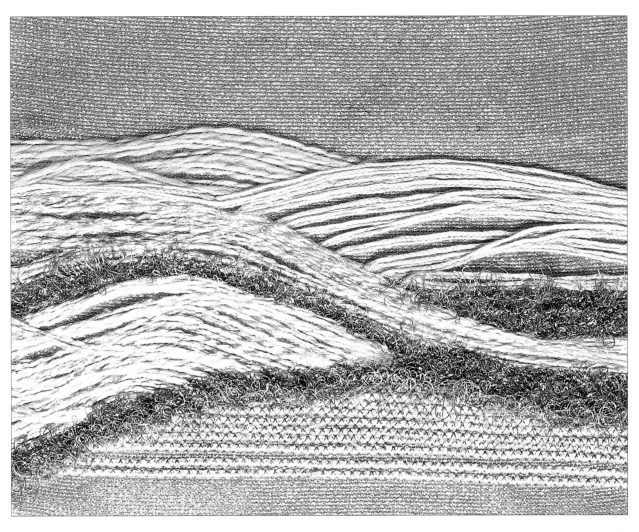

# Tailor tacking foot

The tailor tacking foot has a central, raised bar that produces a line of loops on the surface of the fabric, and must be used with zig-zag stitch. It is the spool thread that produces the exciting textured surface as it passes from side to side over the bar.

Remove the standard presser foot and replace it with the tailor tacking foot. Thread the machine in the usual way, but reduce the top tension. For example, if your normal working tension is 5 reduce it to 3 or the equivalent on your machine. Lower the presser foot lever and make sure the needle is in the highest position before selecting zig-zag stitch, or you may bend the needle. Set the stitch width so the needle passes from side to side, over and just clearing the central bar. Check this before you start to stitch by turning the hand wheel towards you.

The stitch length setting determines how close or how far apart the loops will be. If you use a long stitch length setting the loops will look spiky, while a short stitch length setting produces a line of dense loops. You can, of course, change the stitch length as you stitch.

The technique can be used with shaded, variegated and metallic threads. You can even work it with two threads at once, a method that produces a denser mat of loops, and lets you experiment with exciting colour combinations. If your machine has two spool pins, place a different colour thread on each and thread the machine using them together until you reach the tension disc. Then place one of the threads at one side of the tension disc and the other thread on the opposite side. Continue threading as normal, taking both threads through the needle.

If your machine only has one spool pin, wind a spare bobbin with one of the threads you want to use. Place the reel containing the other thread on top of the threaded spare bobbin and continue as in the previous paragraph.

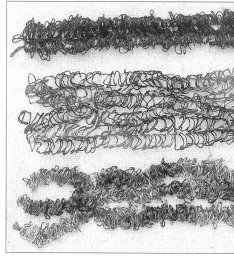

*Tailor tacking showing dense and open loops and two threads through the needle.*

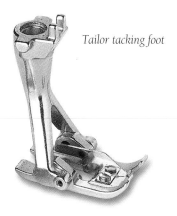

*Tailor tacking foot*

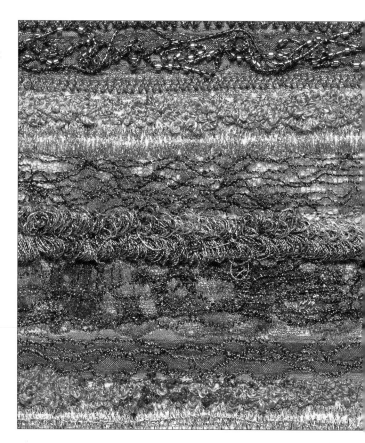

*Lines of tailor tacking were combined with straight stitch, satin stitch, couched threads and applied beaded wire.*

Areas of dense and more open tailor tacking were sewn using shaded and variegated threads. Some of the lines of stitching were done using two threads together in the needle. Torn strips of applied organza were incorporated in the design.

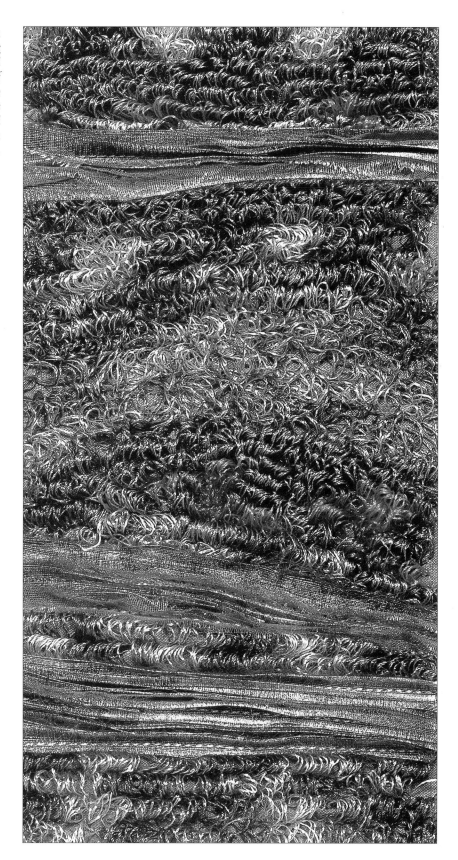

*Selection of suitable automatic patterns but others will work just as well*

## You will need

Two pieces of water soluble fabric
each 13 x 10cm (5 x 4in)

Ruler and pencil

Scissors and pins

Polystyrene tile

Bowl

Machine embroidery threads

Silk fabric for mounting
the embroidery

*Various cold water soluble fabrics*

# Automatic patterns
## On water soluble fabric

Stitching on water soluble fabric is one of the most interesting machine embroidery techniques. After completing the stitching using any technique you choose, the fabric is placed in water. As if by magic, it disappears completely, leaving a lacy network of just the stitches.

Machine embroidery on water soluble fabric is usually associated with free stitching (described in the next sections) but there is huge potential for creative and unusual embroidery using automatic patterns and the standard presser foot. On regular fabric, automatic patterns are somewhat predictable but on fabric that dissolves all sorts of interesting and unexpected textures are achieved.

You do not need a machine that offers a vast range of automatic patterns, as good results can be produced with just utility and basic patterns. The only requirement for success is that each line or area of stitching should overlap and interlock with another. If the lines have not overlapped, there will be gaps in the finished embroidery. If this happens, place a strip of water soluble fabric behind the dry embroidery and add more stitching to join the areas of embroidery, then dissolve the fabric again. If you have never tried working on water soluble fabric, the following steps should guarantee success first time.

Water soluble fabric is available from specialist embroidery suppliers, and there are many types on the market. Some resemble fine plastic film, while others are more like fabric and are easier to handle and stitch. One type requires hot or boiling water to dissolve it, but most people prefer the type that is soluble in cold water.

1. Using a double layer of water soluble fabric, ruler and pencil, draw in a 10 x 8cm (4 x 3in) rectangle for the outer edges of the embroidery.

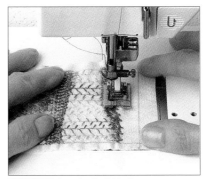

2. Work lines of automatic patterns, each overlapping the previous line, changing the thread colour and stitch pattern as you wish, until the whole area is covered with stitching.

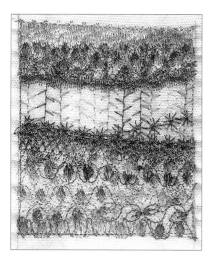

3. Cut off the excess water soluble fabric close to the edges of the stitching.

4. Immerse the embroidery in tepid water, which seems to hasten the dissolving process better than cold, and leave it for a few minutes.

*The water soluble fabric with the completed stitching*

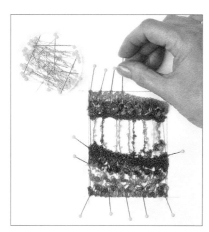

5. Pencil a rectangle 10 x 8cm (4 x 3in) on a piece of paper and place on a polystyrene tile. Remove the embroidery from the water and rinse it thoroughly under a running cold water tap. Pin the embroidery to the tile, easing it to the right size. Leave to dry before removing from the paper.

### The finished embroidery

*A piece of shot silk backing fabric was cut 13mm (½in) larger all round than the embroidery. The embroidery was slip-stitched in place by hand, and the edges of the silk frayed.*

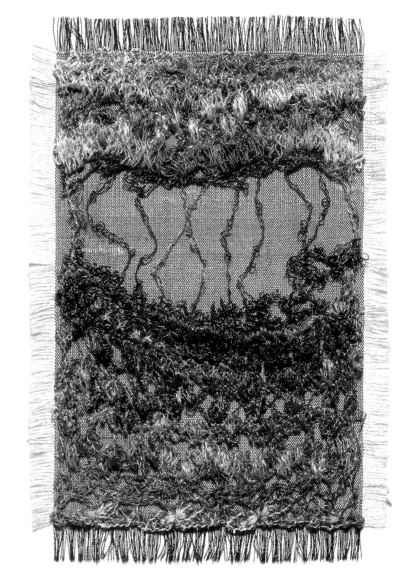

31

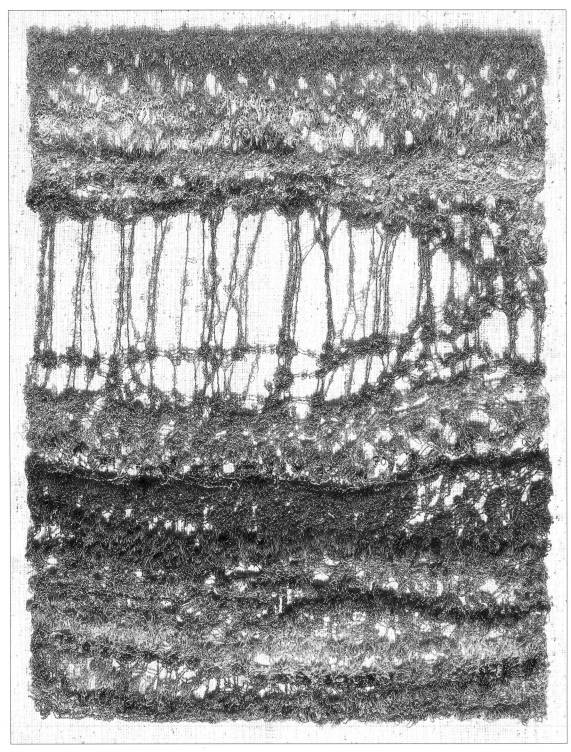

*Variation*

Size: 30 x 20cm (12 x 8in)

*A larger version of the embroidery, showing a greater variety of stitches and colours,
mounted on a slub silk fabric background.*

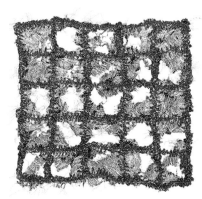

## Variation

*Size: 7 x 7cm (3 x 3in)*

*Fragments of organza were placed between two layers of water soluble fabric and stitched with a grid pattern of straight stitch covered by satin stitch. Satin stitch, on its own, unravels when dissolved, unless it is worked on top of straight stitch.*

## Variation

*Size: 15 x 6cm (6 x 2½in)*

*Simple utility stitches on water soluble fabric produced a very textured, lacy surface. The ends of the thread were used to tie the embroidery over a piece of marbled metallic card.*

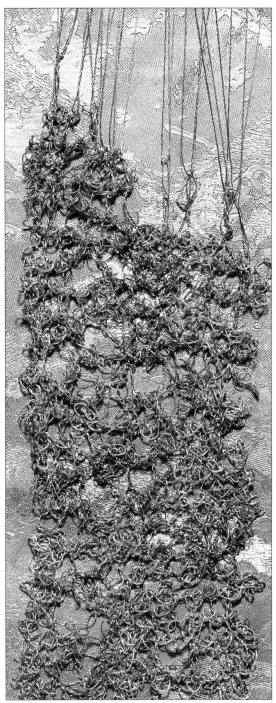

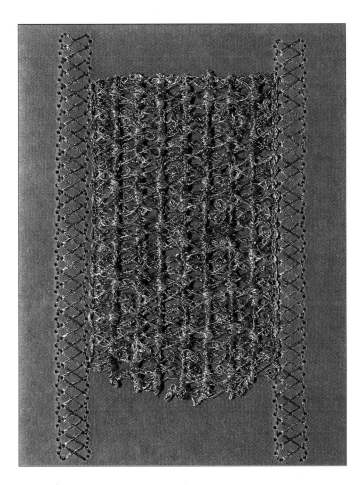

## Variation

*Size: 7 x 12cm (3 x 4¾in)*

*An automatic pattern was worked on water soluble fabric with a variegated thread. The embroidery was placed on a card blank and stitched along both side edges, through on to the card, using the same automatic pattern.*

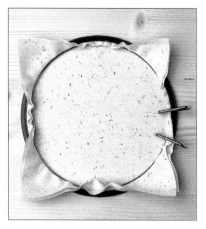

*Detail of sampler shown opposite*

*Fabric framed in metal spring ring frame*

# Free stitching

Some of the decorative effects achieved by machining with the presser foot on and the feed dog or teeth in the 'up' position have already been covered. For many people, however, machine embroidery means free stitching. It opens up whole new areas of possibilities: instead of stitching in straight lines, it lets you stitch in any direction – sideways, backwards or forwards – making patterns and following your own simple design lines. You will need to make some adjustments to your machine: they may seem complicated at first, but with practice, it will only take a moment or two to change from regular to free stitching.

Replace the standard presser foot with a darning foot. Lower the feed dog or teeth – or, on some machines, cover them with a plate, checking the manual if necessary. Choose medium-weight fabric such as calico and place it either in a metal spring ring frame made specifically for machine embroidery, or a small wooden embroidery frame intended for hand stitching. Thread the machine using machine embroidery thread, with the same thread in the bobbin, and use a new size 90 needle. Select straight stitch and set the stitch width and length controls both to '0'. Place the framed fabric under the needle, making sure it rests on the machine bed – the 'wrong' way if you are used to hand embroidery.

Bring the bobbin thread to the surface by turning the hand wheel towards you, dipping the needle into the fabric and back up to its highest position. The bobbin thread will come up just as the needle starts to move down again. Lower the presser foot lever and lower the needle into the fabric.

Hold the two threads and begin to stitch, running the machine at medium speed and moving the frame steadily. If you move the frame quickly you will produce bigger stitches; more slowly and the stitches will be smaller. Try to relax and enjoy seeing how you can alter the direction of the stitching and the size of the stitches you are making.

Try stitching some of the patterns shown right, as well as making up your own variations. You may like to draw simple lines on fabric with a water soluble marker, then see how closely you can follow them. Accuracy is not the aim at this stage, however – it is far more important to enjoy the freedom of the stitching and to be comfortable with the running of the machine and the movement of the frame.

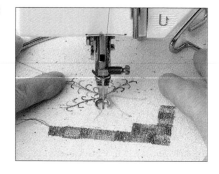

*Free straight stitching following lines made with a water soluble marker.*

*Selection of feet including open horseshoe darning foot and quilting foot.*

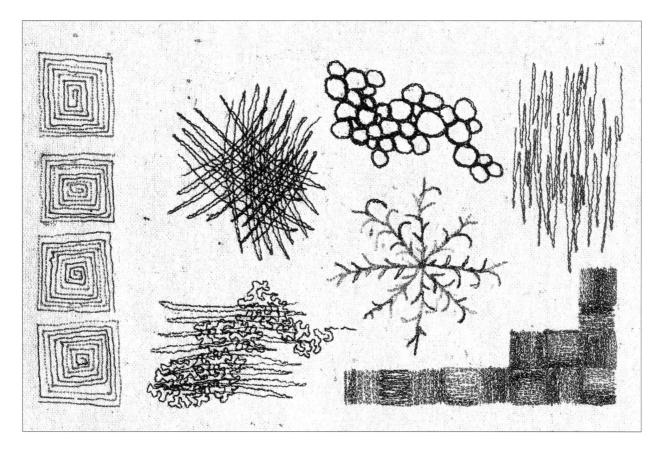

*Sampler showing a variety of stitched patterns using variegated threads.*

## Tips for success

### If a problem occurs while you are stitching, check through this list of 'tips'

1. *Check that the machine is threaded correctly and that the bobbin is the right way round in the race. Check the diagram in your manual.*

2. *Check that the needle is new, is inserted correctly, is not bent and is the right size.*

3. *Check that the fabric is tight in the frame and the frame the right way up under the needle. If the fabric is loose in the frame and the needle makes a 'plopping' noise, it is likely that the machine will miss stitches.*

4. *If the top thread breaks, loosen the top tension a little and check that the thread is fairly new. Old thread becomes brittle with age and will snap more easily.*

You will soon become very familiar with the noise of the machine motor and, if you hear anything unusual, however slight, stop stitching and try to find the cause. Work through the possibilities one at a time and try not to get flustered. It is probably something very simple which can easily be put right.

You may have been aware of slight problems with your machine when doing ordinary sewing. These will become big irritations when doing machine embroidery as you will be running the machine slightly faster and for longer periods of time. So, lastly, make a friend of your local machine dealer and, if in any doubt about your machine, have it professionally serviced.

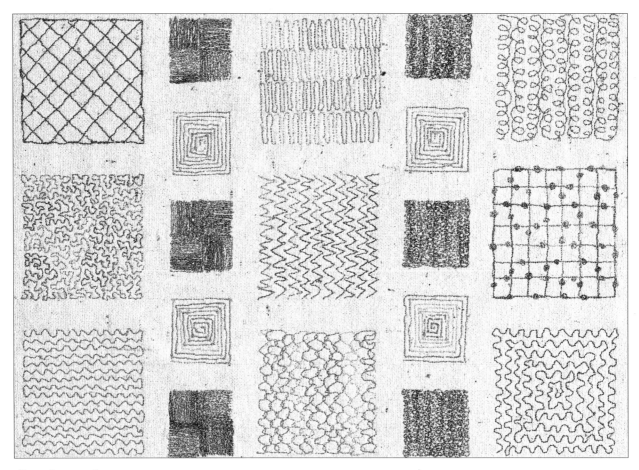

## Stitch sampler

A more ambitious sampler showing more stitch patterns. These include vermicelli, granite stitch, stitching in squares, grids and stitching in curved, wavy and loop patterns.

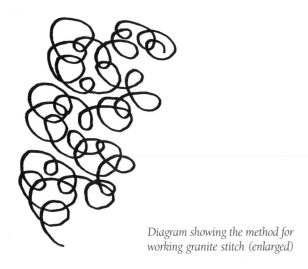

*Diagram showing the method for working granite stitch (enlarged)*

## Granite stitch landscape

*Size: 11 x 15cm (4¼ x 6in)*

*Abstract landscape lines were drawn on to a silk fabric. This was stitched solidly with granite stitch (see diagram left), changing the top colour in the different areas, and leaving small circles of unstitched fabric.*

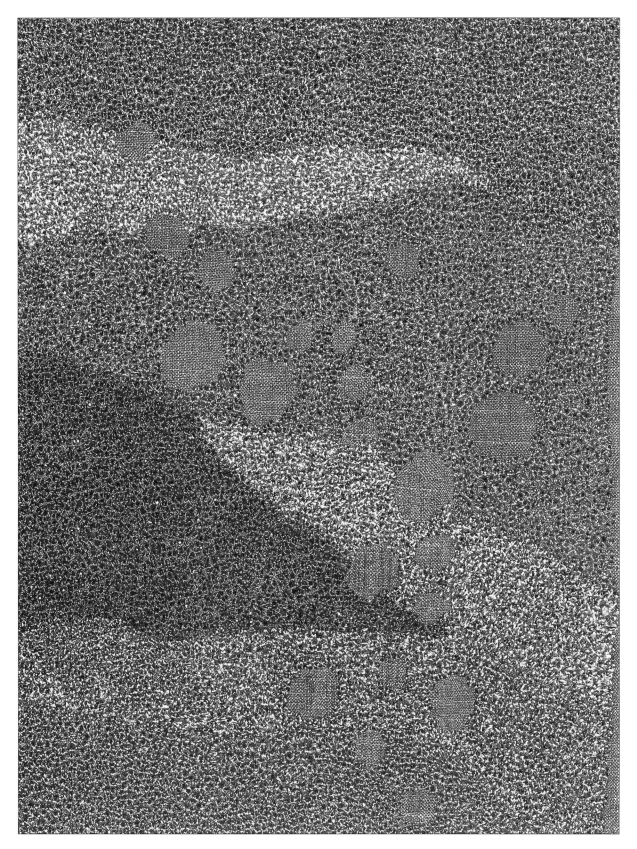

*Detail of the painted fusible mesh shown on page 39*

# Painted fusible mesh

Fusible adhesive mesh is used to bond or adhere two fabrics together. It was developed for use in appliqué work, but there is an exciting way you can use it for colouring fabric. You apply fabric paints to the adhesive side, cut out your desired shape, then transfer the paint to the surface of any fabric, paper or card. It is an easy way to gain experience of colouring fabrics, gives an individual look to your embroidery, and is guaranteed to be successful first time.

The fastest way to paint the mesh is simply to brush fabric paint on the adhesive side of the mesh, let it dry, then cut it out and iron it on to fabric. The project described here takes the process a step further, letting you achieve wonderful mixing and merging of the paint colours. It is based on the 'folded blot' familiar to children in schools, nurseries and playgroups everywhere.

For the project, blobs of different and contrasting colours are placed on one side of a folded piece of fusible adhesive mesh. The unpainted side is folded over, and the mesh is stroked and pressed, allowing the colours to merge. The result is fantastic: red and blue blobs have areas of purple; red and yellow is streaked with orange, and the magic is completed by the addition of metallic fabric paint.

The mesh comes in two weights and, for these projects, you will need the lighter weight. Many different types of fabric paint can be used: some paints intended for silk painting are quite thin and runny and are ideal. Other types are thicker but can be used just as successfully if they are thinned with water. Many brands of fabric paint offer metallics, or colours with a metallic sheen.

## You will need

Fusible adhesive mesh
40 x 20cm (16 x 8in)

Fabric paints

Palette

Dropper

Brush

Scrap paper to protect your work surface

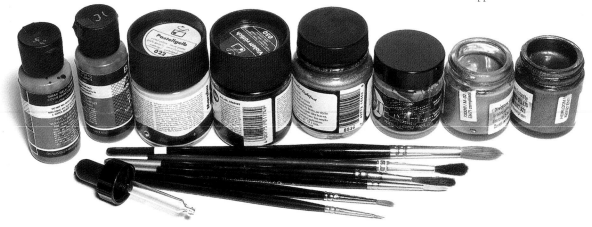

*A selection of fabric paints, including silk paints, fabric and metallic paints, plus brushes and a dropper.*

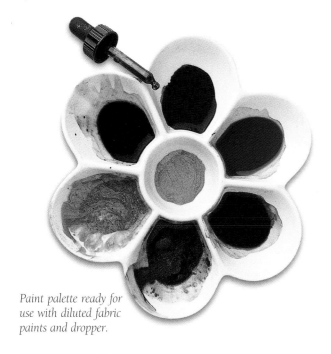

*Paint palette ready for use with diluted fabric paints and dropper.*

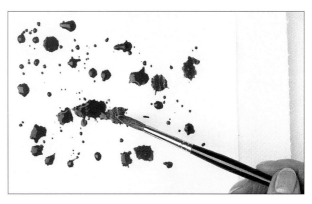

1. Protect your work surface with paper. Fold the fusible mesh in half with the rough 'glue' side on the inside and the smooth paper outside. Crease on the fold and open out. Using either a brush or the dropper, drop blobs of different colours of fabric paint on one half.

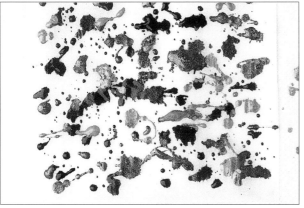

2. Drop all the colours of the paint on to the surface so they are still wet and runny.

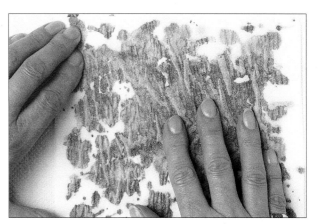

3. Fold the unpainted half of the fusible mesh over the painted section and press and stroke with your fingers, spreading and merging the blobs of paint.

4. Open out the painted fusible mesh and leave it until it is completely dry. You will notice that, as it dries, creases and wrinkles appear in the painted surface, adding extra interest to the final effect.

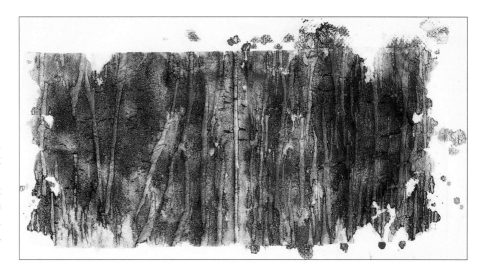

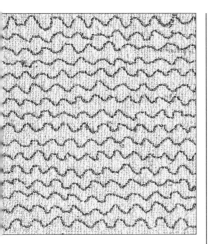

*Wavy stitch lines taken from the sampler on page 36*

# Quilting
## with painted fusible mesh

Quilting gives a lovely soft, padded look to your embroidery, with the machine stitches sinking into the fabric layers. Combine this with applied shapes, such as circles and squares, cut from the painted fusible mesh, and some stylish projects can be worked very simply. You can make the shapes different sizes, or place them in different positions within the squares. Use the stitch pattern taken from the sampler on page 36. If your fabric is delicate, place baking parchment over it before ironing it to fix the circles of painted fusible mesh.

*You will need*

Silk fabric 20 x 20cm
(8 x 8in)

Lightweight wadding
(batting) 20 x 20cm
(8 x 8in)

Calico backing fabric
20 x 20cm (8 x 8in)

Ruler

Water soluble marker

Machine embroidery
threads

Iron and ironing
board

Baking parchment

Painted fusible
adhesive mesh

Scissors

Paper cutting scissors

Cotton reel or coin

Ring frame

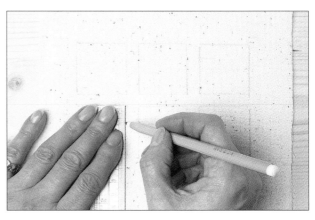

1. Mark circles on the paper side of the fusible mesh using a small cotton reel or coin. Cut out using paper cutting scissors.

2. Mark out a pattern of squares 4 x 4cm (1½ x 1½in) on the silk fabric using a ruler and water soluble marker.

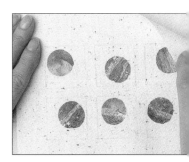

3. Lay the circles in position on the silk fabric painted side down.

4. Iron to fix the circles to the fabric and then remove the paper backing.

5. Place the calico backing on the work surface, then the layer of wadding, and finally the painted silk fabric on top.

## The finished embroidery

The prepared fabrics were placed in a metal spring ring frame before stitching the pattern of wavy lines, using a variegated thread. After stitching, the water soluble marker lines were removed by dabbing with a wet cotton bud.

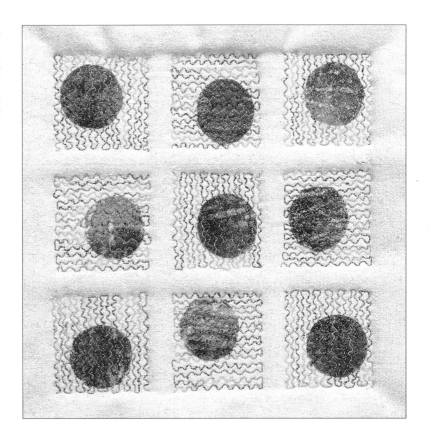

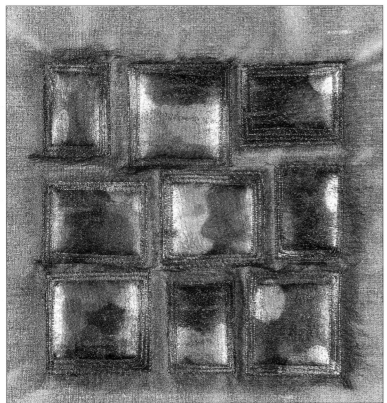

## Variation

*Size: 15 x 15cm (6 x 6in)*

Irregular-sized squares of painted adhesive mesh were ironed on to silk fabric. A piece of chiffon was placed on top and stitched with lines of free straight stitch round each square.

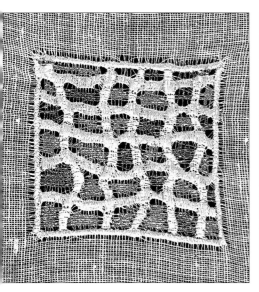

*Free zig-zag stitching on muslin, with the fabric painted after stitching.*

# Using muslin

Muslin is a fine, open-weave fabric that is sometimes called butter muslin. It is a really nice fabric to stitch on but you could also use voile, a lightweight even-weave linen or cotton fabric, or scrim. Fabric paint can be used directly on the fabric as well as on fusible adhesive mesh (see pages 38–39). The small square sample, left, was stitched with free zig-zag, then the fabric was painted afterwards.

Prepare your machine for free stitching (see page 34) but select zig-zag instead of straight stitch, and the widest stitch width. Place the fabric in a frame and stitch outer lines to form a square. Then stitch slightly curved lines within the square, horizontally and vertically, to form a grid pattern. The zig-zag stitching will 'pull' the fabric slightly and distort the weave; in hand embroidery, this is known as drawn fabric. Leave the work in the frame and, with a fine brush, paint the fabric carefully between the stitched grid lines. The technique works best if the fabric paint is fairly thick: silk paint is too liquid and will run in to the stitching. Remove from the frame and heat-set the paint with an iron, following the manufacturer's instructions. A line of these squares along the bottom of voile curtains would look very special.

Drawn fabric can be combined with drawn thread work (see the example below). With a pin, withdraw two threads, then leave approximately twelve threads, remove two threads, and so on in both directions, leaving a pattern of little squares. Place a tiny square of painted fusible mesh on alternate squares and iron in place. Stitch the fabric squares with free straight stitch, vertically and horizontally, which again 'pulls' the fabric. When you are working on fine fabric, try using a thinner (50 or 60) machine embroidery thread, instead of the usual 40 weight. This embroidery would make a lovely insert for the front of a book, or a little pouch bag for a bridesmaid.

### Painted and drawn threads

*Size: 12 x 9cm (5 x 3½in)*

*Small squares of applied painted fusible mesh were alternated with squares of free straight stitch, worked in both directions, on a drawn thread base.*

*Painted and drawn strips*

A pattern of vertical threads was drawn from muslin fabric. Strips of
applied painted fusible mesh were ironed on between the drawn threads,
and alternated with bands of free straight stitch worked sideways, using
a variegated thread.

*Detail of the finished embroidery*

# Painting on fabric

Many of us keep a collection of photographs, pictures from magazines, or our own drawings which we would like to embroider. Often, the biggest hurdle is how to transfer the design to the fabric. In this section, you will discover that machine embroidery makes transferring designs very easy and, combined with fabric paints, opens up new directions for your work.

## Transferring the design

When you have selected the design, you may need to enlarge or reduce it on a photocopier. Take some ordinary white tissue paper and place this on top of the design, pinning or taping it in place. Trace the design through on to the tissue paper, using a felt tip pen or gel-based marker. As you will be stitching along these lines, I advise choosing a pen of the same colour as the thread you intend to use, just in case any of the pen colour marks the thread.

Take a fabric, such as calico, and place the tissue paper on top. Place it in a ring frame and prepare your machine for free straight stitch (see page 34) with the same variegated thread on the spool and in the bobbin. Stitch along all the design lines, but do not worry if the tissue perforates and starts to break away from the stitching – this just makes the next stage easier. When all the design lines have been stitched, tear away any remaining tissue and you will find a perfect copy of the design stitched on your fabric.

The next step is to look at the stitched design and decide which of the areas enclosed by the stitching you would like to paint, which you would prefer to stitch, and which to leave as plain fabric. Using one or more colours of fabric paint – the thicker type is best – and a fine brush, paint the selected areas, taking the colour just up to the stitched line. Let the fabric paint dry completely, then heat set it with a medium to hot iron.

Check that the machine is still set for free straight stitch, and use the same variegated thread. The stitching should follow the contour lines of the design shapes, in parallel lines, until the shape is filled. It does not matter if your lines are not exactly parallel or if the distance between them varies slightly: these little irregularities add individuality to your work. The outer lines round the embroidery are worked in satin stitch with the presser foot on and the feed dog or teeth in the 'up' position.

*A page from my sketchbook showing drawings of ivy leaves, border patterns and a counterchange design.*

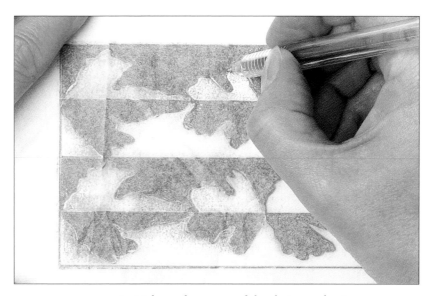

## You will need

Drawing or design

Calico fabric, size 20 x 15cm
(8 x 6in)

Tissue paper

Felt-tip pen or gel-based marker

Variegated machine
embroidery thread

Fabric paint and fine brush

Ring frame

Iron and ironing board

1. Make a photocopy of the design, enlarging or reducing it if you wish. Cover with tissue paper and trace the design, using a felt tip pen or gel-based marker.

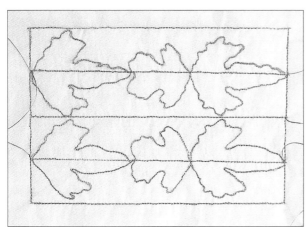

2. Place the tracing on your fabric and stitch through the tissue paper, following all the design lines.

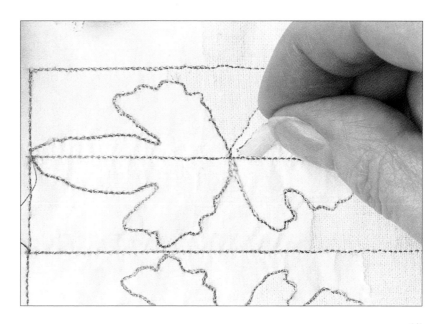

3. Tear away the tissue paper from between the stitched lines.

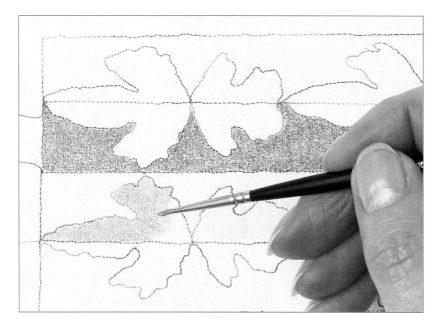

4. Using fabric paint and a fine brush, paint in areas of the design. Leave to dry, then heat set ther colours following the manufacturer's instructions.

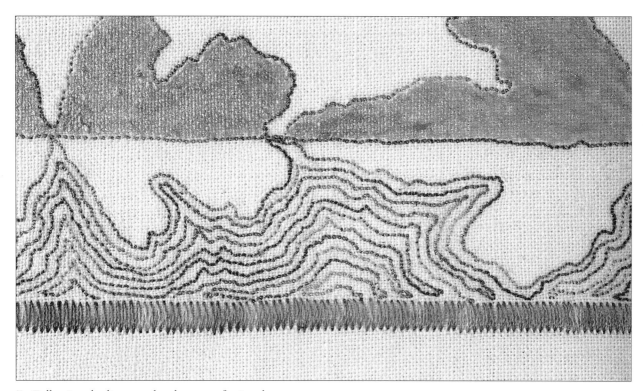

5. Following the lines made when transferring the design, add close parallel lines of free machine embroidery until the areas are completed.

*Opposite*

## The finished embroidery

*The outer lines of the stitched areas have been completed using satin stitch in the same variegated thread, using the ordinary presser foot and the feed dog or teeth in the 'up' position.*

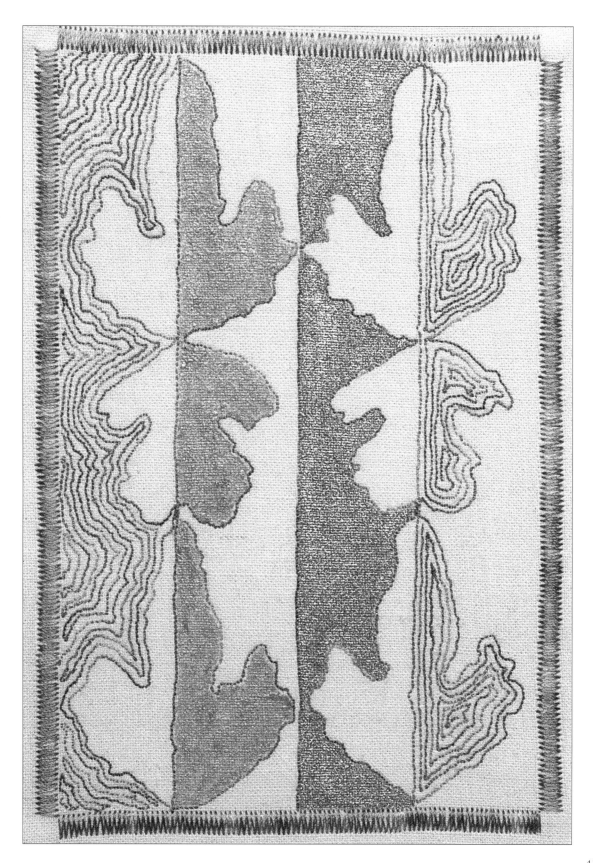

# Layered fabric

## You will need

Medium weight fabric, cotton, calico or silk, 30 x 20cm (12 x 8in)

A piece of fusible adhesive mesh the same size

Selection of sheer fabrics such as organza, net, chiffon and fine silk

Iron and ironing board

Baking parchment

Scissors

Machine embroidery thread

This technique produces a lovely, decorative fabric that can be used alone or as a background for further stitching. The combination of sheer fabrics and fusible adhesive mesh is the same as for densely-stitched fabric (see page 18) and satin stitch (see page 22), but achieves a very different effect.

Layered fabric begins with a medium weight background fabric such as silk, cotton or calico. Cut a piece of fusible adhesive mesh and place it on the fabric, with the smooth paper side uppermost. Then iron with a medium to hot iron and remove the paper backing.

Now comes the fun part: gather a selection of different types of sheer fabric including organza, nets, fine silks, chiffon, metallic and novelty fabrics and tear them into narrow strips. Most woven fabrics will tear, giving attractive, slightly frayed edges. It helps if you make a little snip on the edge with sharp scissors then, holding each side of the snip, tear quickly and very firmly across the fabric. Arrange the torn strips on the background fabric, allowing them to curl and overlap each other. When you are happy with the arrangement, cover the whole area of the fabric with a piece of baking parchment. Iron with a medium to hot iron, then peel off the baking parchment.

The layers of fabric look good just as they are but, for added durability, add lines of machining using free straight stitch. Many people prefer to stitch without a frame on firm fabric. It allows you to see the whole of your work and you are not restricted to the area within the frame. As the layered and bonded fabric will be quite firm, this is a good opportunity to try free stitching without a frame. Have the darning foot in place and hold the fabric firmly at each side while you stitch. Let the lines meander along the strips and between the different colours to add texture to the decorative surface.

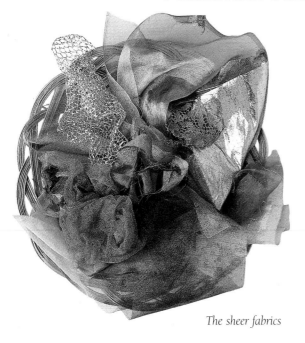

*The sheer fabrics*

1. Iron the fusible adhesive mesh on to the background fabric. Tear a selection of sheer fabrics into strips and arrange them in a pleasing pattern.

2. Cover the torn fabric strips with baking parchment and iron them in place, then remove the baking parchment.

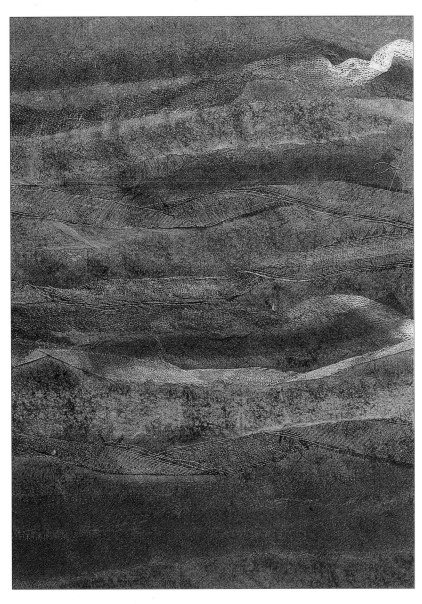

*A variation of the layered fabrics, using darker colours and including torn strips of silk metallic organza.*

## Variation

*Strips of sheer fabric were bonded on to background fabric and stitched with free straight stitch in meandering lines.*

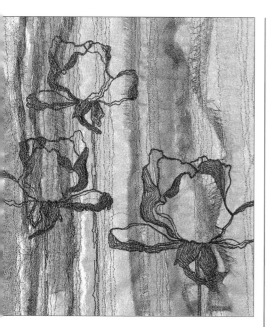

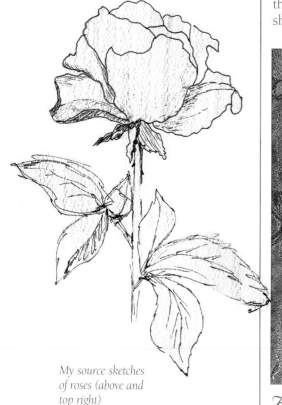

# Flowers on layered fabric

Throughout the centuries, flowers have been used as a design source for all types of embroidery. The layered fabric technique shown on the previous pages makes the perfect background for an embroidery of summer roses. Enlarging or reducing the drawing will give you flowers of different sizes, or you may choose to embroider just one flower.

To transfer your design, use the tissue paper method (see pages 44–45) and trace off the outline shape of the flower, including the lines of the petals. Prepare your machine for free straight stitching and decide whether or not you wish to use a ring frame. Select some machine embroidery threads in the colours of the rose, including some paler and darker shades. Some of the lines on the samples shown were worked in a slightly heavier silk machine embroidery thread to give more definition.

After the design lines have been machined through the tissue paper, tear it away and continue stitching. Fill in some of the petal shapes with close lines of stitching to indicate areas of shading. Metallic threads are available in colours as well as gold, silver and copper, and the addition of a few lines in a coloured metallic thread adds life and sheen to the flower.

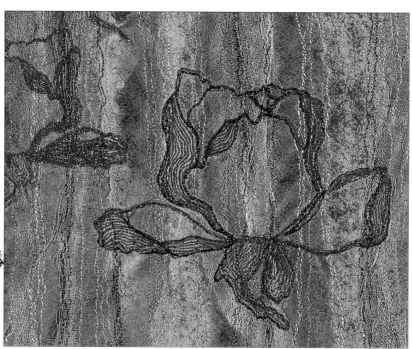

*My source sketches of roses (above and top right)*

## Finished embroidery

*Layered fabric backgrounds with roses embroidered using a variety of threads including silk and coloured metallic machine embroidery threads.*

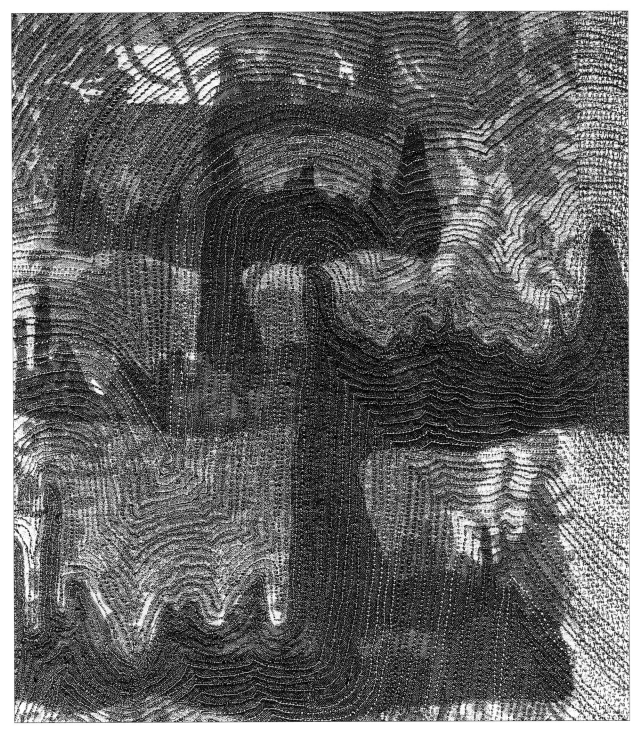

## Layered quilted fabric

*Abstract shapes cut from organza were overlapped and bonded to patterned background fabric. One of the cut shapes was followed for the first line of stitching. Remaining lines were worked parallel and close to this line, and continued over the whole embroidery. The thread colour was changed every three or four lines.*

# Silhouettes

Many parts of the world have a fascinating legacy of embroidery and design. India is a rich source of inspiration, an example being these charming drawings which are used as quilting patterns. They depict the lives of women going about their daily tasks, and *The Water Carriers* is an ideal choice as a silhouette pattern for appliqué.

Enlarge the drawing to the required size and cut a piece of fusible adhesive mesh, a little larger than your drawing. This will be used in the same way as tracing paper. Place the fusible mesh over your drawing, adhesive side down and paper side uppermost. Use a pencil to trace the *outer lines of the pattern only* on to the fusible mesh.

Choose a fabric such as silk or fine cotton for the appliqué. Place the fusible mesh on the fabric, adhesive side down, and iron with a medium to hot iron. Do not remove the paper backing at this stage.

With sharp, fine scissors, cut all round the silhouette pattern on the pencil line. Select a background fabric such as medium weight silk or cotton. Place the cut-out pattern on the background fabric, adhesive side down, and iron to bond the appliqué. Now remove the paper backing and the appliqué is ready for stitching.

In the finished examples shown, the work has been quilted with 2oz wadding and backing fabric, but this is not absolutely necessary. Prepare your machine for free straight stitch, darning foot on and feed dog or teeth lowered. Thread the machine, spool and bobbin, with a toning thread and place the work in a ring frame. Stitch round the silhouette outline, just inside the edge of the appliqué. An alternative method is to machine embroider all over the background, going just over the edge of the appliqué in places to secure it. The ideal stitch is vermicelli, a meandering line that twists and turns but does not cross over itself (see page 54). It takes a little time and practice to master, but it could well become your favourite stitch.

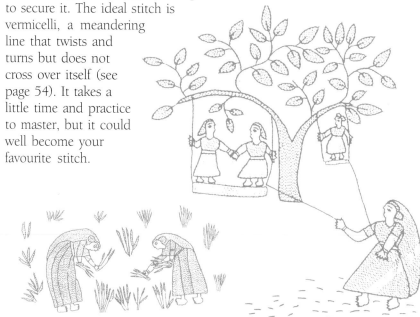

*The sketches on these pages were inspired by a calendar produced by a women's cooperative in Bihar, India.*

1. Trace the outline of the drawing on to the paper side of fusible adhesive mesh. The drawing also shows a suggested border pattern of overlapping water jugs.

*My outline sketch*

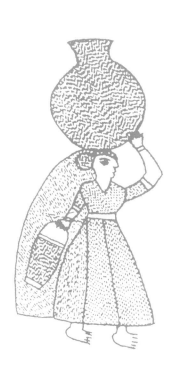

2. Place the fusible adhesive mesh pattern on top of the appliqué fabric and iron it in place.

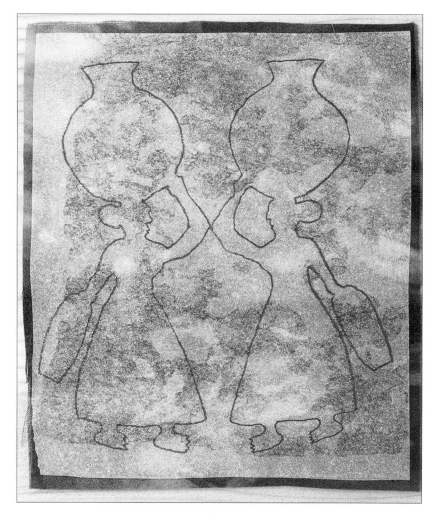

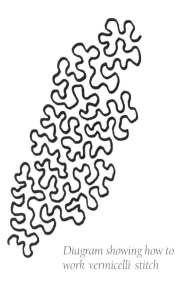

*Diagram showing how to
work vermicelli stitch*

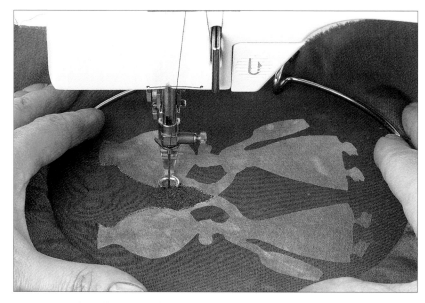

3. Cut out the silhouetted figures and place on the background fabric. Iron the appliqué on to the fabric, place it in a ring frame, and start to stitch the background areas using vermicelli stitch.

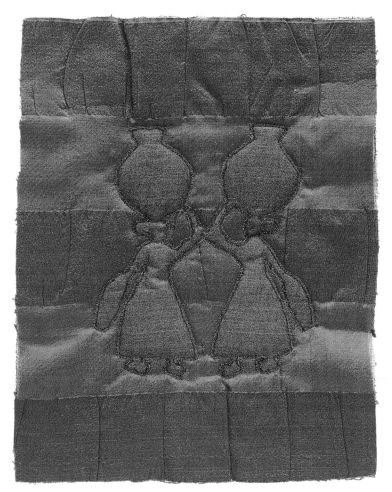

### Variation

*The appliqué was placed on a striped silk
background fabric and outlined with two rows of
free straight stitch.*

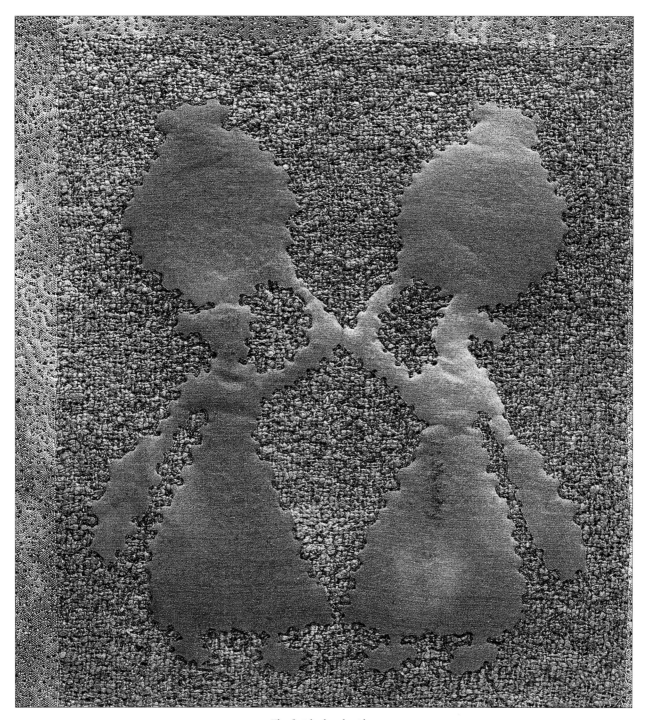

*The finished embroidery:*

## The Water Carriers

*The space-dyed silk appliqué was applied to a
background of loosely-woven raw silk, and
completed by stitching the entire background with
a dense pattern of vermicelli.*

*My original sketch showing variegated ivy leaves.*

*Ivy leaves worked in free straight stitch, with several changes of spool colour.*

# Using sketches

The thought of using your own sketches for machine embroidery may be daunting, but nothing is more satisfying than interpreting one of your own drawings – however simple – in stitch. Inspiration is all around: it could be the shading on a variegated leaf, the pattern of tree branches against the sky, or a much-loved landscape. The marks and textures made by a pen or pencil are easily recreated using machine stitches such as straight or zig-zag, and you will have the satisfaction of producing a truly original embroidery.

A different approach to colour has been taken for the landscape opposite. The stitched areas look orange, purple and green but no threads in these colours were used: it shows colour mixing, which the sewing machine does brilliantly. The orange areas are stitched with two threads in the needle (see page 28). You may need to reduce your top tension a little to accommodate what is effectively a thicker thread through the needle. Red and yellow used together look orange, but the effect is far more vibrant than one colour used alone. Green areas are mixtures of yellow and blue. The purple areas are mixtures of red and blue, and show lovely colour variations that result from changing from dark red to light red but keeping the same blue in the needle.

First, transfer the lines of your sketch to the fabric using the tissue paper method (see page 45), or colour different areas of a landscape on to fabric using wax crayons or fabric paints. Wax crayon colours can be uninspiring, so try this method:

Lay torn strips of paper across the fabric to create the main landscape lines. Rub a wax crayon on your finger to transfer some colour, then gently stroke it over the torn paper edge and on to the fabric. For a more subtle effect, blend two or more wax colours on your finger. Overlap and merge the coloured areas on the fabric.

Prepare your machine for free stitching and decide how to work different areas of your design. Parallel lines of straight stitch fill an area effectively. Bands or lines of narrow zig-zag produce a more textured appearance. Moving the frame from side to side as you work zig-zag gives a softer effect. The little 'bumps' or satin stitch blobs in the foreground are worked by stitching back and forth in zig-zag, hardly moving the frame. Threads are brought to the surface and tied off to add even more texture. Choose the thread colours carefully and change the spool colour as often as necessary.

### Landscape

*Size: 15 x 20cm (6 x 8in)*

*This was worked on a background of calico coloured in part with wax crayons. Individual areas were worked using straight and zig-zag stitch and the techniques described above.*

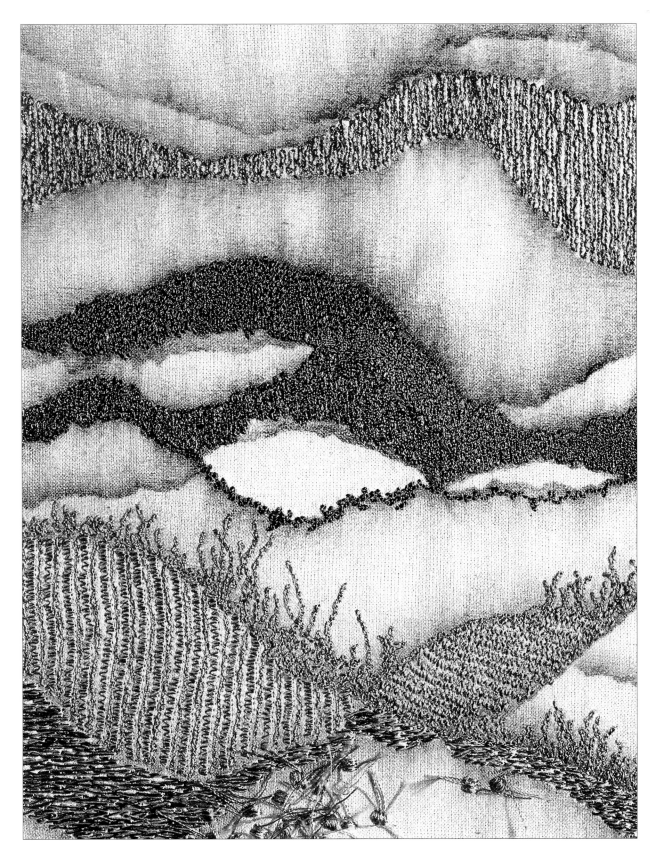

# Ribbons

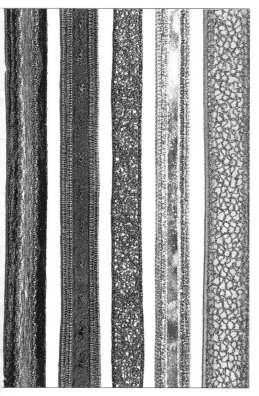

*A selection of machine embroidered ribbons worked on water soluble fabric.*

Making ribbons on a machine is easy and amazingly effective. Ribbons you make yourself are far more interesting and original than anything you can buy. They can be used to decorate clothes, accessories and items for the home, and an embroidered ribbon tied round a present makes it very special. Choosing fabrics and threads yourself ensures that they add the perfect finishing touch.

All the ribbons shown left were worked on water soluble fabric. Using granite stitch leaves a lovely lacy pattern when the soluble fabric has been dissolved. You can also work ribbons on narrow bands of sheer fabric. If you do this, a base of water soluble fabric will stabilise the stitching and also allow you to work in a ring frame if you wish.

Begin by drawing parallel lines, the required width of the ribbon, on water soluble fabric. Then try working one of these suggestions:

1. Fill the area with granite stitch, working a line of narrow zig-zag down both edges on the marked lines.
2. Turn under and press narrow hems on both sides of a strip of organza. Pin or tack in place on the water soluble fabric and stitch with vermicelli or lines of automatic patterns.
3. Apply a strip of painted fusible adhesive mesh down the centre of a fine silk fabric and work lines of satin stitch over the side edges.
4. Cut a narrow strip of fabric such as organza or fine silk, including the selvedge. Cut in half and overlap the cut edges so the selvedge forms each side of the ribbon. Work lines of automatic patterns down the centre to cover the cut edges.

When the stitching is complete, trim the excess water soluble fabric from the sides of the ribbon. Immerse in tepid water for a few minutes. Rinse thoroughly and, when almost dry, iron with a medium iron.

## Making cords

When making cords to complement a bag, use thicker threads such as wool, No. 3 or 5 perlé cotton, fine braid or metallic yarn in complementary colours Prepare your machine for free stitching with the darning foot on and the feed dog or teeth lowered. Thread with a toning or contrasting colour, or a metallic thread, using the same thread both on the spool and in the bobbin.

Select the maximum width of zig-zag stitch. Hold the cord thread firmly at the back and front and stitch over it, easing it through smoothly and evenly.

Make several cords, varying the colours of both the cord thread and the machine thread, and attach to the sides of the bag.

***Note:*** *when you start to stitch machine wrapped cords, it is best to hold the two machine threads to prevent them disappearing down the race and round the bobbin.*

# Bags

Little bags are an ideal way to try some machine embroidery techniques, while producing a very special project. The simple method below uses some of the techniques covered earlier.

Mark out a bag shape on one side of a folded piece of water soluble fabric. Sandwich a few fabric fragments (sheer, foil, net or metallic) between the folds.

Prepare the machine for free straight stitching, using thread that complements your chosen fabrics both on the spool and in the bobbin. The bobbin colour can remain throughout, but you can change the spool thread as often as you wish to build up areas of different colours.

Place the folded water soluble fabric in a ring frame and stitch in a meandering, lacy pattern of loops and circles. The fabric fragments add stability, but make sure the stitching overlaps and is connected with other lines of stitching. Finish by working one or two lines of stitching round the outer marked lines to firm and secure the edge. Work another piece in the same way for the back of the bag. Finish as shown on page 31.

The embroidered pieces can simply be joined and finished with cord to produce a delicate, lacy bag. Beads sewn round the edges are an attractive finishing touch. You may also like to line your work with fine silk fabric.

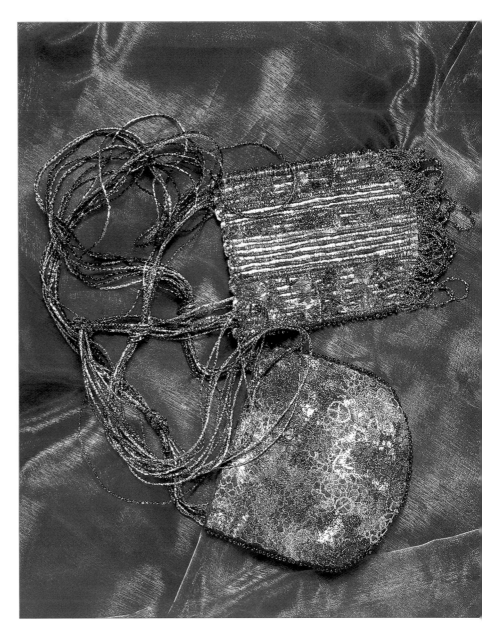

## Two little bags

*The turquoise, pink and purple bag (below) was worked on water soluble fabric with added fragments of sheer fabrics, free stitching, a beaded edge and machine wrapped cords (see the method opposite) for the handle.*

*The bronze bag (above) was worked in the same way but the stitched embroidery was cut into strips and applied by machine to a ribbed silk fabric. It was finished with a beaded fringe and a machine wrapped cord handle.*

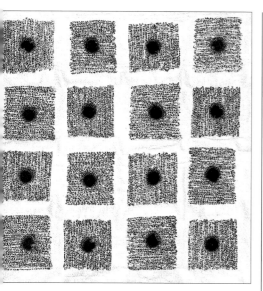

*Squares of free running stitch were worked on silk fabric using metallic thread. The central hole in each square was burned through from the back using a pyrography pen.*

# Beyond fabric

Learning to use your machine for embroidery is exciting, and we all know that the first step is to be confident with the basic techniques. Once these have been mastered, however, a whole new world of creative possibilities opens before you. This section covers some of the ideas that push the boundaries of machine embroidery 'beyond fabric'.

It is rightly presumed that sewing machines are made to sew fabric but the machine does not know – or care – what it is stitching on! It stitches just as well on brown wrapping paper or tissue paper, on fine metal or foil, over wire, into knitted wire and, indeed, on nothing at all! A machine just stitches. But I care dearly for my machines and would never stitch something really thick or unsuitable. If in doubt, do not try it: your machine is far too precious to risk damage.

A first glance at these examples might give you the impression that weird and wonderful alterations have been made to the machine to achieve these effects. Surprisingly, the stitching is exactly what has been covered in the previous chapters: straight and zig-zag stitch. Some machine techniques do require altering the upper and lower tensions or winding thick threads on to the bobbin. Such things strike unnecessary fear into the heart of the beginner but to start with, all that is needed is familiarity with straight and zig-zag stitch.

## Metal and wire

Small quantities of fine, soft metal are available from specialist embroidery suppliers, in various colours and weights. Another product, wire mesh, is woven metal that cuts and sews like a fabric. Some ingenious embroiderers even use soft metal cut from discarded tomato purée tubes or soft drinks cans!

Metal is great fun to use, but make sure it is integral to the embroidery rather than just a 'gimmick' used for effect. Before you use it, try distressing the metal surface to reduce the shine a little. Mark, scratch or dent the surface with a hammer or the point of a stiletto – it is a wonderful way to relieve stress! Heating the metal over a flame will change its colour, but remember to hold the metal with tongs as it can become very hot. In general, use a large (size 100 or 110) machine embroidery needle when stitching on metals. Size 110 needles are often sold as 'jeans' needles.

Wire is equally interesting to use, and is now sold to embroiderers in various weights and lovely colours. Try machine wrapping it with zig-zag, using the same technique as for wrapped cords on page 58.

## Knitting with wire

This is an interesting technique. I find that SWG (standard wire gauge) 34 is ideal, or you could even try 5-amp fuse wire!

Use medium to thick knitting needles and cast on about six stitches in the usual way. Work in garter stitch. It will feel strange to begin with, as wire does not 'give'. The aim is not to produce perfect knitting but interesting texture, though it can be quite hard for expert knitters to learn to knit rather badly with lots of loops and dropped stitches!

Machine-wrapped wire such as fuse wire can also be used to make little round beads. Take a short length, and twist it tightly round and round a knitting needle. Push or poke the ends of the wire into the middle of the bead and slip it off the needle.

# Conclusion

I hope that some of these ideas will fire your imagination and lead you to discover more and more about machine embroidery.

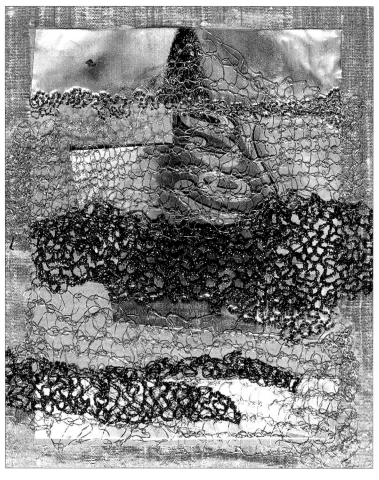

### Abstract landscape

*16 x 14cm (6¼ x 5½in)*

*Pieces of knitted fuse wire were placed between layers of water soluble fabric. Some areas were stitched using black and gold metallic threads. After dissolving, it was placed on heat distressed metal and brown wrapping paper and further stitching added. Finally it was stitched on to a background of grey dupion silk.*

### Ribbons and beads

*Size: 15 x 15cm (6 x 6in)*

*Purchased gold and silver metallic ribbons with a black edge were manipulated, twisted and folded. Fusible adhesive mesh was used to apply them to torn strips of organza on a silk fabric background. Wire beads (see above) were threaded on machine wrapped wire, which was bent in a zig-zag pattern and hand-stitched in place.*

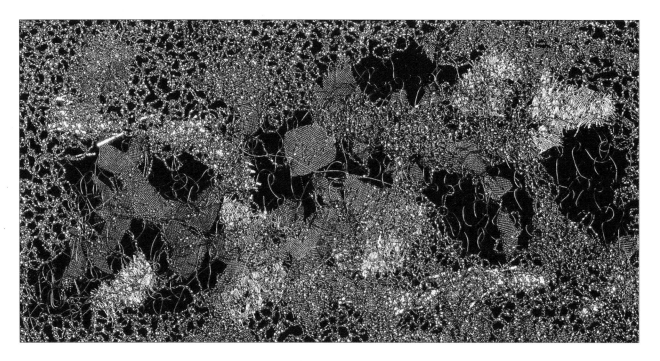

## Foil and wire

*Size: 15 x 9cm (6 x 3½in)*

*Fragments of metallic foil, organza and knitted red wire were placed between two pieces of water soluble fabric and stitched with granite stitch using a metallic thread.*

Note: this piece has been photographed on black fabric to emphasise the detail.

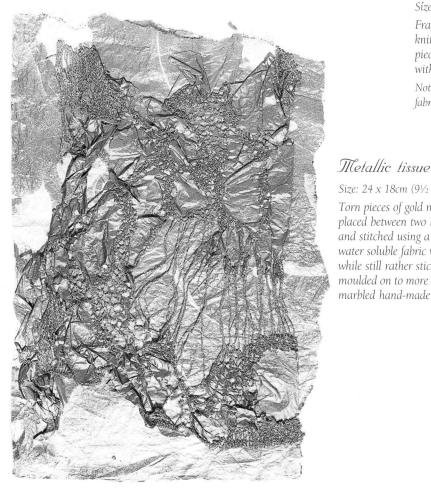

## Metallic tissue

*Size: 24 x 18cm (9½ x 7in)*

*Torn pieces of gold metallic tissue paper were placed between two layers of water soluble fabric and stitched using a gold metallic thread. The water soluble fabric was only partly dissolved and, while still rather sticky, the embroidery was moulded on to more tissue paper, then on to a gold marbled hand-made paper background.*

*Opposite*

## Organza and gold

*19 x 14cm (7½ x 5½in)*

*Layers of patterned organza were stitched and cut back to reveal layers underneath. Gold wire was knitted to fit some of the shapes and applied to the surface.*

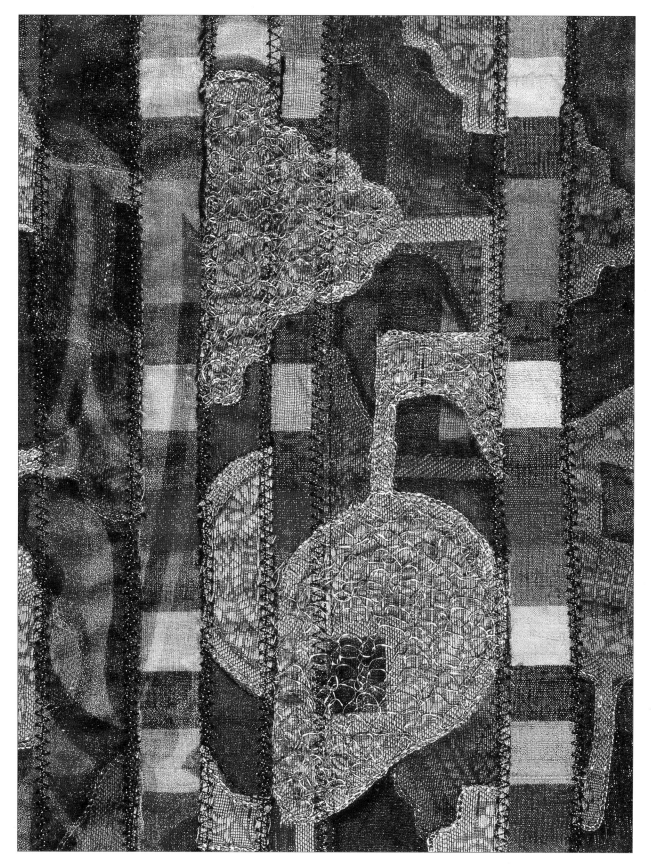

# Index

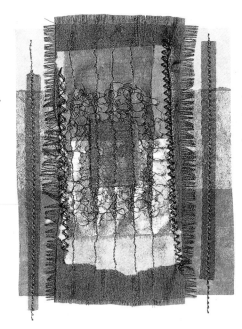

## Five layers

*14 x 10cm (5½ x 4in)*

*Chinese metallic paper was topped with fine silk fabric, then gold-painted paper, a piece of knitted wire and finally a tiny square of wire mesh. Strips of wire mesh were added at each side and lines of machine stitches sewn through the layers.*